professional
web site design
<from start to finish>

professional
web site design
<from start to finish>

< anne-marie concepción >

HOW DESIGN BOOKS
CINCINNATI, OH
www.howdesign.com

Library of Congress Cataloging-in-Publication Data
Concepcion, Anne-Marie
 Professional website design from start to finish / Anne-Marie Concepcion.
 p. cm.
 Includes index.
 ISBN 1-58180-130-0
 1. Web sites—Design. 2. Web site development. I. Title.

 TK5105.888 .C656 2001
 005.2'76—dc21 2001024292

Edited by Kim Agricola and Clare Warmke
Cover design by Real Art Design Group, Inc.
Interior design by Clare Finney and Wendy Dunning
Interior production by Linda Watts
Production coordinated by Kristen Heller

The permissions on pages 156–157 constitute an extension of this copyright page.

About the Author

Anne-Marie Concepción is the president and creative director of Seneca Design & Consulting, Inc., a Chicago-based graphic design studio she founded in 1987 primarily as a legitimate excuse to play with her Macintosh all day. (She has since gone bi-platform.)

These days, Seneca Design & Consulting specializes in cross-media communication—print, Web and Acrobat CD-ROM projects—for over 150 clients, including the International Housewares Show, R.R. Donnelley & Sons, the *Chicago Sun-Times*, *World Book Encyclopedia*, the Joyce Foundation and the American Academy of Orthopaedic Surgeons.

An early addict to the online world, Concepción has been a member of AOL since 1991, and was active on GEnie, eWorld and CompuServe—Concepción welcomed the dawn of the Internet with open arms. She hand-coded her first client Web site in BBEdit in 1996, an experience she describes as akin to completing *The New York Times* crossword puzzle without a pen or pencil. Currently, Concepción and her team of designers use a variety of Web-authoring tools to create highly interactive, imaginative sites for her clients and have expanded into hosting the sites as well.

In between Web and print projects, Concepción takes on a number of side gigs. She does quite a bit of customized training for design/production professionals in studios, publishing companies and ad agencies across the country, pulling on her experience as a teacher in a former life (she has a master's degree in education from Northwestern University) as well as her "real-world" credentials. Concepción is a long-time certified trainer for Adobe Photoshop, Adobe GoLive and QuarkXPress, and teaches a number of other design programs as well.

Also a prolific freelance writer of magazine articles (*HOW*, *Publish*, *Digital Chicago*, *X-Ray*, *Step-By-Step Electronic Design*), Concepción has contributed to the books *Photoshop Filter Finesse* (Random House) and *The Mac Bible* (Addison-Wesley), and even wrote the definition of "Desktop Publishing" which has appeared in every edition of *World Book Encyclopedia* since 1994. She also comes up for air every once in awhile as a speaker at industry conferences and trade shows.

Concepción is the single parent of a teenager who has absolutely no interest in Web design albeit is pretty handy at downloading MP3s.

Dedication

To Mom,
who reads everything I write,
including what's between the lines.

Acknowledgments

After over ten years of magazine writing, finally getting the opportunity to author a book feels very sweet—but it leaves me with a long list of people to acknowledge with my heartfelt thanks for their support and encouragement over the years. They tell me I only have a few paragraphs worth of space here, so if I've neglected to mention you, it was my editor's fault, not mine! <grin>

I don't think I'd be writing this today were it not for Jennifer Dees, founder and publisher of *Mac/Chicago* magazine (which she has since sold to the *Chicago Sun-Times*, who continued to publish it as *Digital Chicago* and *Digital New York*). Back in 1990, Jennifer responded to my long-winded "Letter to the Editor" with a reply e-mail, asking if I would be interested in contributing an article to the next issue. Her enthusiasm, whip-smart intelligence and deft editing pen nurtured my growth as a writer for her publication, and others, for many years.

Of course I'd like to thank Lynn Haller, the original F&W Publications acquisitions editor who e-mailed me in late 1999 to say that she was a longtime fan of my Web design columns in *Publish* magazine, and to ask if I'd be interested in writing a book on the subject for them. This is known as the "no effort" approach to getting a book contract! When she saw that I was wishy-washy about the proposed outline, she came back with, "Just write the very best book you can about Web design, exactly what you think people should know and can't find in other books, and we'll create an outline from that." I knew this was my kind of publisher.

When Lynn left F&W, Kim Agricola picked up the ball. She was the editor who did the actual work of wrestling with my manuscript and honing it into shape. Kim is the opposite of what first-time authors fear in a book editor; she was unfailingly kind, supportive and understanding throughout the process.

Thank you to David Blatner, Sandee Cohen and Joe Grossman; three stellar designers/writers whose books are an inspiration and whose generous spirits have always been there for me; to the good people at the National Writers Union and its Chicago chapter for supporting freelance writers through its advocacy and intelligent contract advice; to my longtime compadres John Claussen and Dan McEachern, partners in the Chicago Web development firm Energés, for leaning on their clients to fasttrack their permissions for many of the coolest Web site screenshots in this book; to my graphic designer friends Annette Krammer, Maria Sitelis and Tom Goodman whose feedback on the rough drafts helped make the final draft something I was proud of and to all the members of the Chicago WebGrrls chapter whose wild enthusiasm for the book kept me going when the words were fighting me (and who helped inspire the title now on the cover).

Finally, thank you to my clients, my family and especially to my cherished daughter and best friend, Nicole, for cutting me some slack throughout the months when this book was my only topic of conversation.

Table of Contents

< table of contents >

Smart Web Design

< introduction >

"My boss wants me to take over designing and maintaining our Web site. Can you teach me?"

"I'm ready for a career change, and Web design sounds like a good field. Does it take a long time to learn?"

"Our print design clients want us to do their Web sites, but we don't know anything about it. Is it hard to do?"

As a seasoned Web designer and software trainer, I'm used to these questions. The problem is, I always feel put on the spot. I can hear the implication in the questioner's voice. Each person who asks is hoping I'll have the same brief, reassuring response: "No problem! If you buy X (a $150 Web-authoring program), and throw me some bucks for a half-day of training, you'll be all set."

I have to fight against the temptation to tell them exactly that, because—in a way—it's true.

You can buy any one of dozens of inexpensive programs that will help you lay out a Web page visually. You can grab graphics for your site off of sites that offer free, public-domain Web art for buttons, backgrounds and icons. You can hire me to step you through putting together a few pages in your program of choice, linking them together and uploading them to your Web server. Technically, that's Web design.

But this is also Web design:

- Choosing a domain name, reserving it and protecting it; finding a Web host provider that offers you or your client the most bang for your buck
- Figuring out the purpose of the Web site and its goals, and how you'll know if you've achieved those goals
- Developing a site that—through its graphics and content—attracts and retains its intended audience
- Knowing which features of your Web-authoring program will work for your site visitors and which won't
- Making the site look appealing, worthy of repeat visits and with the same layout, despite being viewed by people on different browser software, different connection speeds, different platforms and different reasons for being there
- Devising a site structure and way to move around it that makes sense and that ideally has some creative flair
- Converting existing communications to Web format in a Web-savvy way
- Knowing when to bring in outside vendors, such as programmers, Flash

gurus and database jockeys, and knowing how to choose the best ones for your purposes

- Keeping links updated; maintaining and modifying your site and ones you've inherited
- Measuring traffic on the site, getting it noticed by search engines, and promoting the site on and off the Internet

What I'm explaining here is *professional* Web design. Strategies and skills that are impossible to package into a half-day training session, yet are critical to the success of all Web designers and the sites they create.

Don't think by "professional" I mean only people who design big corporate sites for a living; on the contrary, we've all seen some horrendous sites—ones that are unusable, even while visually pleasing—done by "professional Web design firms."

Instead, by professional Web design I mean applying an appropriate amount of strategic thought and logical, efficient production practices to the design and development phases of any site, big or small, personal or corporate, so that you end up with something that looks good, works well and gets the results desired by the site owner.

What I described above also means *smart* Web design, because by using professional-level skills, the sites you'll create—whether for your personal interests or your company's top clients—will get produced with a minimum amount of tearing of hair and rending of garments.

Will this book teach me how to create clean HTML and fast-loading graphics?

So far I've made little mention of the usual Web design book topics like HTML coding intricacies or the virtues of JPEGs vs. GIFs. I don't consider these issues to be critical for our purposes, although I do briefly address them throughout the book—especially in the discussion of production in chapter four. I don't go into great detail about them; it would be like including the contents of a dictionary in a book about how to write well.

Of course, every writer should have a dictionary close at hand. Just like the spell checkers in word processing programs don't entirely replace the need for a bound dictionary, Web-authoring programs are not yet so seamless as to obviate the need to

know HTML. Techniques for creating or tweaking HTML and Web graphics are comprehensively covered in dozens of other books and hundreds of Web-based tutorials, and you'll probably want to have at least of few of these resources available. I list my favorite books and tutorial sites in the Appendix* under General Resources.

Alternatively, if you're a project manager or simply an overbooked Web designer, you may want to hire out the design concepting and/or the coding tasks. This book will help you structure the workflow and approval stages of a Web development project, allowing you to strategically delegate and manage the tasks involved.

How is this book arranged?

Tasks involved in Web design and development are approached chronologically. The very first thing you must do is configure your workstation, reserve a domain name and set up an Internet dial-up and Web host account for you or your client; so that's covered in chapter one. (If you're already set up, you can skip this section.)

The book progresses through the strategic thinking and content development phases, then covers prototyping and proofing design concepts, marches on to actual page and graphic production, goes on to publishing the site on a Web server and concludes with the follow-up tasks of publicizing your site and maintaining it.

Each chapter is more or less self-contained, so it's not necessary to read chapters chronologically, even though they're arranged that way. This makes it easy to zero in on the tasks you really need help with. Further, Web jockeys across the spectrum should be able to find valuable information suitable to their level of expertise, since I've written the chapters so that they provide professional-level content understandable by greenhorn Web designers.

The Appendix includes a list of my favorite resources for Web design: books, Web sites, mailing lists and associations. The first thing you learn as you develop Web sites is that a new learning curve is constantly looming before you, so staying connected to the Web developer community is essential to your success. The resources listed in the Appendix are the ones I've found to be most useful to my own Web design business, and I think you will find them useful too.

I'm talking to you

I'm writing this book as though you called me up and asked for help with your Web site. It's a very personal, informal style. Although I frequently address you as a Web designer working with "your client," just about everything I say is applicable to anyone working on Web sites—whether as sole developer, team member, employee or professional designer.

So if you're developing a site for your own use, "your client" is yourself; if you're a staff member who's working on the company Web site, "your client" is your boss or your peers.

*The author maintains an up-to-date version of the Appendix on her Web site at www.senecadesign.com.

```
function changeto1()    {
document.layers["text"].document.write("<fo
color=blue><a
href=http://www.urlhere.com>Link

                    document.close();

<head>

<script language="JavaScript1.2">

function changeto1(){
setTimeout(changeto1,   "1");
}
function changeto1()    {
document.layers["text"].document.write("<font
color=blue><a
href=http://www.urlhere.com>Link
       </a></font>");
```

gearing up

Setting Up Your Workstation

Obviously, you need to be able to connect to the Internet and surf the Web if you want to design successful Web sites. You need to see what other people are doing with their sites, especially those that are similar to the ones you want to do. Free tutorials, information-rich discussion forums and mailing lists exist mainly online, and you'll want to access those. And, of course, at some point you'll be uploading (transferring from your local computer to a remote Internet Web server) the files you've created for your sites, which is impossible to do without an Internet connection. Web hosting companies will not accept your files on disk.

To connect to the Internet, you need to have a computer, a modem, a phone jack and an account with an Internet Service Provider (ISP) for basic Internet access, also known as a dial-up account. Since you're a Web designer, you'll want the fastest modem, a dedicated phone line (one just for your modem, separate from your voice line) and an account that doesn't penalize you—charge you extra—if you are connected for extended lengths of time, more than the "average surfer."

If you're working for a company, chances are you already have all of these. However, if your company is not currently using its systems for Web development, or if you'll be creating Web sites outside of work hours from your home office, you may need to purchase new equipment or upgrade what you have.

Computer

Whether your system of choice is Macintosh or Windows (either is fine for site design), it's imperative that you find a way to get access to both. The sites you create will look different and act differently when viewed on different platforms, even if you use the same exact browser version software on both. It's a sad fact of life for any Web designer.

Since you'll need to be able to preview, tweak and preview again your sites so they look and work basically the same cross-platform, a cross-platform setup is essential.

At a minimum you need a buddy who uses "the other" platform and is willing to let you use it to test your sites under production. You'll quickly tire of this, let me tell you, but at least you get a chance to circumvent platform-specific issues before unleashing your sites to the world at large.

The better option is to have both types of computers on site. You can pick up used but serviceable Mac or Windows-based computers for under $500 from a variety of sources. They don't need to be speed demons or have huge hard drives, but they do need to be able to run the latest browser software for their platform.

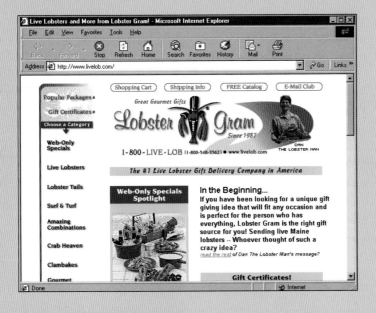

See what your audience might see

Web designers need to have the hardware and software capabilities to preview Web sites as seen in different browsers and on different platforms. Here are excerpts from the same page seen on four different browsers. Note how the live text block (lower right starting with "In the Beginning...") appears differently on each.

The browsers from top to bottom are:

Internet Explorer 5 (Windows)

Netscape 4 (Macintosh)

Netscape 4 (Windows)

AOL 5 browser (Macintosh)

Ideally you'll set them up with their own connections to the Internet, so you can upload test files to your Web server and view them "live" from both computers. If you can't or don't want to connect the other computer to the Net, then you'll need to either: 1) copy files to the other computer's hard drive from a floppy or Zip disk and preview them locally (choose Open File from your browser's File menu) or 2) set up a local staging server (like an in-house Internet) that both computers can access over your local area network.

Macintosh users also have the option of running Windows emulators (software-only versions) on their Mac using Connectix's Virtual PC or Insignia's SoftWindows; or for more money and a bit more pep, as an add-on board from OrangeMicro. Whichever solution you choose, it works the same: When you start up the Windows software, a

Macintosh users can install Windows emulation software so they can preview sites in Windows right from their Macintosh. Here I've opened Netscape 4 in Windows 95 on my Macintosh using Insignia Software's SoftWindows. (Note the Macintosh menu bar on top.)

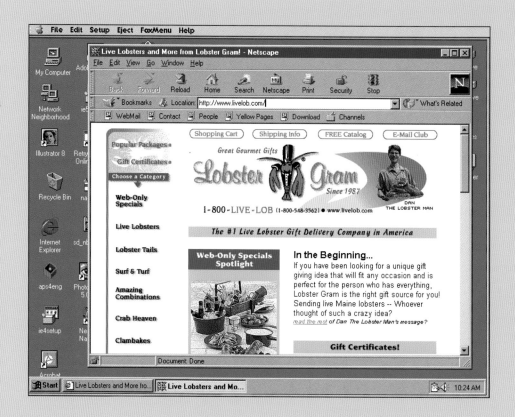

window opens up and looks like the desktop of a Windows computer. From there you can install Windows software, connect to the Internet and surf the Web using Windows versions of Netscape, Internet Explorer or America Online (AOL), and so on. The Mac OS still runs in the background, allowing users to switch back and forth between the two operating systems from the Application menu. Each operating system can share the same modem connection. This is an ideal solution if you're short on desk space. The Windows-user will also be interested in Executor, a Mac emulation program for Windows. See the Appendix for contact information.

Modem

Faster is better, of course. At a minimum you'll want a 56K modem (the fastest available as of this writing), and if you can get a cable modem or a Digital Subscriber Line (DSL) connection, all the better.

A cable modem offers very high-speed connections at a reasonable price. However, since cable connections are shared with other local subscribers, they can pose a security risk. A DSL is a high-speed, "always on" digital connection linking a computer's network port to a digital modem and from there connecting to the local phone company via a consumer-grade phone line (usually dedicated to this

purpose). If you go with cable or DSL, try to get one that lets you upload as fast you download, since you'll be uploading a lot of files to Web servers. (Most consumers don't need fast uploads, so many cable companies and DSL providers will attempt to keep this speed very low to save themselves some bandwidth.)

If you're going into the Web design business (or you're already in the thick of it), I recommend that you install both a DSL or cable modem and a 56K modem, and maintain dial-up accounts (see below) for both. That way, if your high-speed provider is having some problems with its lines, you're not completely cut off from your livelihood—just reconnect through your 56K modem. This type of equipment redundancy always pays off at some point, if only by lowering your daily stress level.

Setting Up Your Accounts

Dial-up

The basic kind of Internet account you'll need is called a "dial-up" account that you can set up with an ISP. Look for ISPs in the yellow pages and in ad sections of industry magazines. Some of you might also find an ISP through free "trial subscriptions" that you'll possibly receive with your computer purchases.

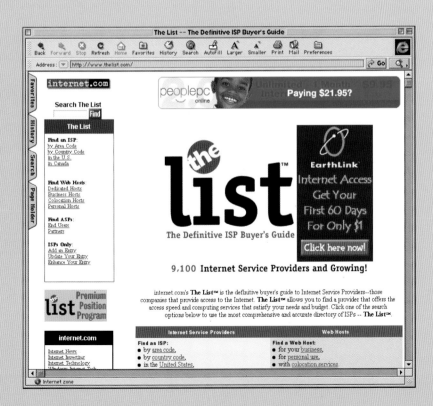

One way to find a good ISP or Web host provider is to use the search engine at The List (www.thelist.com). You can search by geographical region, price, features and more; and you can compare these across a number of competitors.

Can't I Just Use America Online?

America Online (AOL), currently the largest online community in the world, works some-what the same way as the ISPs described here. Since you can access Web pages using the "AOL Gateway," technically AOL can be termed an ISP. You get a local phone number, an account name and password, and an e-mail address. However, AOL restricts you to using their software for connecting and to their e-mail software, which so far is inferior to popular e-mail software such as Microsoft Outlook and Eudora that you can use on regular ISPs. For this reason, and because of a number of other restrictions on their service, Web designers should opt for a regular ISP account. (As my Mom says, "Hey, it's a write-off.")

By the way, you can still use your AOL account even if you get a dial-up account with an ISP. (You'll soon find that a surprising number of client company upper-management types use AOL to access the Internet, so you might as well set up/keep up an AOL account for yourself so you can test your site with the same finicky browser they'll be using.) After you connect to the ISP's network, start up your AOL software and choose Connect Via TCP/IP (see screen shot on facing page). This tells AOL that you're already connected to the Internet so their number doesn't have to be used. If you'll always be connecting to AOL this way, you can reduce your AOL billing charges to $9.95/month or less—visit AOL's Member's Area to find out more.

In exchange for paying the ISP a monthly fee—typically $10 to $20 per month for unrestricted (untimed) access, which is what you want—they give you an account name, a password and a local phone number for your modem to dial up. Your modem connects to their very high-speed Internet connection, and from there, to the Internet at large: the Web, e-mail, newsgroups and File Transfer Protocol (FTP) servers. (An FTP server is a Web-accessible computer that stores files and allows people to transfer files from their local computer to the server and vice-versa, using an FTP utility program.) For Web design purposes, FTP is normally used to transfer files to and from the designer's workstation to the Web host company's Web server.) You also get at least one e-mail address that uses the ISP company's name as the domain—for example, yourname@ispname.net. Frequently the ISP will provide you with free or Shareware versions of all the software you'll need, preconfigured with their settings.

Web host

Your Web site can't be made available to Internet users at large until it's placed on a Web server connected to the Internet. Almost every dial-up ISP offers a second kind

of Internet account, called a Web host account. When you add this service from an ISP company, you're given space on its Web server (a computer that stores and shares Web site files) to file your personal Web sites, but you can also set this up to hold your client's or your company's Web files. Web host companies usually have very powerful and secure Web servers, as well as the highest-speed, redundant connections to the Internet. (A dedicated Web host account is different than the one or two MB of Web server space that some ISPs offer free with your dial-up account. This space is used mainly for personal pages or as a place to experiment and get your feet wet with Web publishing.)

To access your reserved space on an ISP's Web server, the ISP will supply you with a user name, a password and the address you'll need to access the server for copying files over with FTP software.

Charges for Web host accounts range from $10 to $500 per month, depending on how much space you'll need for your Web files (20MB? 2000MB?) and how much traffic your space can support. But unless you plan to upload the next Yahoo, you

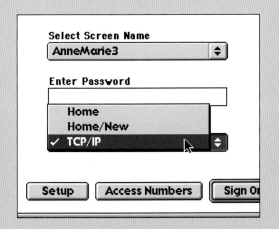
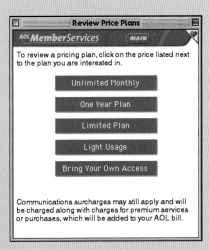

Since so many people access the Web via their AOL account, it's probably a good idea to set one up for yourself even if you already have a dial-up ISP account—that way you can preview your sites under development via AOL just as much of your audience will.

If you've connected to the Internet via your ISP, you can also connect to AOL without having to dial in to their network—just choose "TCP/IP" from the Connect Via menu. AOL will give you a price break on your account ($9.95/mo. vs. $22.95/mo.) if you plan on almost always connecting to them this way. Just go to Keyword: Billing and change to the "Bring Your Own Access" pricing plan.

should be fine starting out with an account in the $25 to $50 per month range. You can always upgrade if necessary.

The ultimate upgrade—short of becoming an ISP yourself—is to set up a co-location account with a Web host. That means you buy the Web server computer, but they keep it at their site and hook it up to their existing "fat pipes" network. You get total control over how and what the server runs, while at the same time you can rely on their 24/7 tech administration to ensure the server is safe, secure and connected to the ISP's fast Internet connections.

It's not necessary to use the same ISP for your dial-up and your Web host accounts! In fact, a rapidly growing segment of the ISP industry is companies that only host Web sites. Without the need to support all those dial-up connections, Web host specialty companies frequently offer better rates, better services and more features for Web developers. You'll find these kinds of companies listed in trade magazines, Web sites about Web design and e-mail listservs. ("Listserv" is the technical term for subject-specific, subscriber-based mailing lists based on e-mail. Messages sent to a listserv address get copied and sent to all subscribers' e-mail addresses.)

Domain name

You've no doubt heard by now that domain names (like "www.yourcompany.com") are doled out first-come, first-serve. If you want a particular domain name that someone else has already registered in their name, then you're out of luck—unless that party is willing to sell it to you. (If you can prove that the name is your trademark and that you used and protected your trademark before the other party registered the domain name, then theoretically the domain registration company should release it for your use—but that's a subject for another book!)

When Do I Register My Domain Name? Search for an available name and register it for yourself or your client as early in the process as possible. Why give some other mope a few weeks to take your perfect name while you're developing the Web site? There is no "use it or lose it" rule with domain names; even if you never create a Web site that uses it, the name remains yours as long as you continue to pay the fee to the domain name company.

Who Do I Register With? The Web is replete with domain registration companies. But be careful! While many companies advertise domain registration services at bargain basement rates, in reality they're registering the name themselves and then turning around and leasing it to you (or your client). Since they own it, you can't transfer the domain to another Web host or prevent them from canceling the lease, nor can you sell the domain name to someone else should you so choose. To ensure

that you're dealing with a truly qualified domain registration service—one that will grant you full ownership over the domain name—choose one of the twenty-plus registered and qualified vendors listed on the ICANN Web site's Appendix. ICANN (Internet Corporation for Assigned Names and Numbers) is the regulatory agency created to manage the domain registration industry after Network Solutions, the company that originally managed this area, was forced to give up its monopoly. Rates for domain name registration are about the same—usually $20 to $40/year per domain name—regardless of which ICANN-approved vendor you choose.

Protect Your Domain Name From Theft! Virtually all the steps involved with securing, confirming and modifying a domain name registration occurs via e-mail, and it all hinges on the e-mail account you designate as the main contact point (usually yours or your client's). Since enterprising hackers can fairly easily configure an e-mail message so it looks like it's coming from you, they can do all sorts of things by communicating "on your behalf" with the online registration company. So when you set up your domain name registration, choose the highest level of "modification security" to protect your registration info from being modified without your consent.

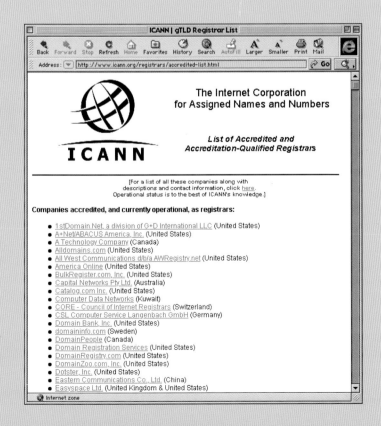

The assignment of domain names is going through a controlled deregulation at the moment. Network Solutions (aka "InterNIC") is no longer the only player in town. The ICANN organization was set up to oversee the deregulation and is the only certifying body for domain name resellers we have. Go to their site to choose an "ICANN-authorized" domain name reseller, or check to see that the one you've chosen appears on their list.

Efficient Bookmark

When you're assembling your online resources, simply choosing Add Bookmark or New Favorite won't cut it. To achieve an efficient bookmark collection, follow these tips:

1.

Spend some time developing a logical organizational approach to categorizing your sites using the Folders feature of your browser's Bookmarks module.

2.

Give your bookmarks clear names—don't just accept the default page title names.

3.

Periodically go through your list and cull the ones that are outdated or off-line.

4.

Once you exceed five hundred bookmarks or so, you'll find the browser is having a hard time keeping up. Then it's time to export everything to a software utility designed to manage bookmarks. (I use URLManager Pro for the Mac; see the Appendix for contact information.)

Bookmark, Bookmark, Bookmark

Netscape Navigator, Microsoft Internet Explorer and other Web browser programs allow you to save the URLs (Uniform Resource Locators, a Web page's unique "address") of Web pages so you can easily recall them later. Netscape calls this feature "Bookmarks," which has become the popular term. Internet Explorer calls them "Favorites."

Inspiration

While you're working on your Web site, you should be consciously seeking out exemplar Web sites to serve as inspiration. Look for sites that have cool effects you'd like to achieve, or ones that present their information in a logical and creative way—sites with unique and innovative navigation schema.

Competition

If you're about to create a Web site for a particular company or organization, or working on a proposal for the same, search out as many sites as possible that belong to that company's competitors. Consider how you can improve on the field.

With an objective eye, check out your favorite sites and see how the developers have made sure that you are being communicated with not just by the content, but also the structure and design message of the site. (See the next chapter for more about structure within sites.)

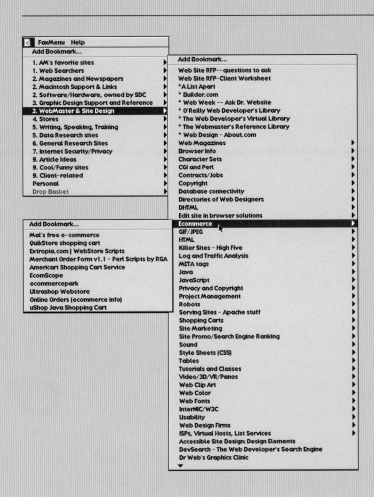

(left) Five years of Web surfing has resulted in a bookmarks list of more than 1,000 great URLs. It'd be difficult to find the one I need, though, if I didn't take the time every month or so to sort them into logically named folders.

(above) A commercial URL management utility, like this one called "URL Manager," is essential for managing large numbers of bookmarks.

Help References

Finally, bookmark sites that will help you with Web design: tutorials, software support, design portals, clip art, type sources and so forth. When you're deeply involved with a project and facing a deadline but need to know some arcane bit of information ("How wide is a standard banner ad, in pixels?"), you'll be glad that you bookmarked that Ad Age site listing standard banner sizes. I include my favorite list of online resources for Web site designers in the Appendix.

```
function changeto1()  {
document.layers["text"].document.write("<fo
color=blue><a
href=http://www.urlhere.com>Link

                    document.close();

<head>

<script language="JavaScript1.2">

function changeto1(){
setTimeout(changeto1,   "1");

function changeto1()  {
document.layers["text"].document.write("<font
color=blue><a
href=http://www.urlhere.com>Link
here</a></font>");
```

essential pre-design tasks

Let's start out with a real-world analogy.

My sister and her husband were a little concerned that their four-year-old son wasn't showing much interest in learning how to read. So when the next gift-giving opportunity arose, "Super Aunt" (that's me) presented her nephew with one of those cool quasi-computer toys designed to make education fun for little fingers. This particular contraption looked like a brightly-colored laptop computer with a handle. When you opened it up, the bottom half had a colored keyboard with all the letters in upper and lower case clearly marked on the keys. The "screen" was a piece of blank plastic on which you propped various cardboard lessons.

The simplest lesson is learning the alphabet. The cardboard insert shows a capital letter and a picture of something that starts with that letter, and kids are supposed to then find the matching letter on the keyboard and press it. If they are right, they hear the toy's HAL 9000 (generic computer voice) pronounce the letter and the sound it makes; then HAL says "Good!" or "Right again!" If they are wrong, HAL responds by pronouncing and sounding out the incorrect key's letter; then HAL adds something like, "Sorry, try again."

I thought it was a perfect place to start.

Very excited with his toy computer, my nephew Scotty and I tried the first lesson together: a picture of a frying pan and a capital and lowercase letter P. "Fwyer! To

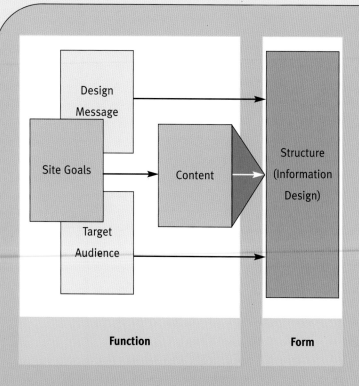

Function

Form

Pre-design site development flowchart

The most important thing to determine with any Web site project are the goals—WHY does the client want to put up the site? What do they hope to gain? Upon what basis will they determine its success or failure?

The Design Message (the "image" a site is trying to convey) and its Target Audience are closely related to the Goals and should be integrated within them.

Based on the Site Goals (which take audience and design message into account), the Content—graphics, text and interactive features—should be developed.

Finally, the structure of the site—how pages link to each other, how deeply pages are buried, how people can navigate—is based upon the content, obviously, but also upon the design message and the target audience. A professionally designed site has a structure that takes into account both the hierarchy of its content as well as how its target audience will access that content.

fwy food!" he shouted. I responded, "That's a frying *pan*, Scotty. Pan starts with a 'puh' sound, the letter P. See the shape of the P here? Can you find the letter P on the keyboard?" He quickly scanned the keyboard and mistakenly stabbed the key marked Bb.

Rats! I should have seen that common error (b for p) coming and headed it off at the pass. Too late—HAL said, "B, buh, try again." (Well, *I* heard HAL say b, but Scotty heard him say p. Cheap voice chip.) Scotty sighed and said, "I *said* p!" and he pressed the B key again, harder. "B, buh, try again," HAL intoned. "What's wrong with this cwazy thing?" Scotty said. "Is it bwoken?"

Think First, Then Design

The lesson here is that no matter how cool something looks, if it doesn't work for the intended audience then it will fail. The toy manufacturer's intended audience was clearly pre-literate kids like Scotty. But the toy wasn't designed to fully accommodate their special needs for clear, unambiguous pictures and quality voice feedback.

If you want to create a Web site that works, you need to ensure that form follows function. The purpose of the site should guide its form (its design)—not the other way around.

To figure out the site's function, you and your client need to be clear about four things:

- *The goals of the site:* What is its purpose? What does the client hope to gain?
- *The design message:* What does the client want to communicate via the "look" of the site?
- *The intended audience:* Who is the client trying to reach?
- *The content:* What specific information—for this audience, for this goal—must the site provide?

Armed with that knowledge, you are ready for your final pre-design task: site architecture, also known as information design. This is developing an optimal site structure—how the content will be arranged within the site, as in a storyboard or flowchart—that will be useful and intuitive for its intended audience, and will help the client meet their goals.

For a small entry-level site, you and your client might spend ten minutes discussing the site's goals, its design and its target audience. They hand you a printout of what they want the site to include; you sketch out a simple storyboard; they say, "Fine"; and you head off to design. Done and done in one meeting.

Learn From Other's Mistakes

Surf around the Web for a while with your critique antennae "on" and you'll find it easy to tell when a client and their Web design team faltered on the pre-design work. As a member of a site's target audience (such as a general category like "gardeners who buy seeds from Web sites"), assuming that you're using a standard browser, you've probably confronted the following problems at one time or another:

- The type is too small to read.

- You can't find the information you're looking for.

- The site is confusing and you get "lost" in it.

- Your browser crashes.

- You need a plug-in (which you don't have) to do basic things.

- The graphics consistently take way too long to appear.

- You don't understand what you're supposed to do.

- The text content is too superficial (or too voluminous) to be useful to you.

- You're looking for something standard (e.g., a "Contact Us" page or an "Add to Cart" button) and it's just not there.

These are all hallmarks of an insufficient Web development process that skipped essential elements of the pre-design phase.

The other side of the coin: Want to see some examples of sites that did do the right amount of planning? Look at your browser's Bookmarks or Favorites menu. Apparently these sites work so well that you were impelled to save their addresses. Take a closer look at your "favorites of the favorites." I'll bet you find that at least a few of these sites are somewhat lacking in design sophistication—and you're a designer by trade! Are you starting to see what's important to your "real" clients...the Web site's target audience? The sophistication and originality of the site's design are nice to have, but functionality, entertainment, ease of use and/or compelling content almost always take precedence.

At the other end of the spectrum, you might be dealing with a Fortune 100 client's first knock-em-dead megasite. In that case you'll probably want to devote at least a few weeks—or months—to conducting client and customer interviews, running focus groups, analyzing competitor sites and conducting surveys before you ever plunk a pixel on the screen.

Of course, most projects fall somewhere in between those two extremes. Before figuring out a Web site budget for your company or a quote for your client, decide

how much pre-design work will be required and how it will be conducted (meetings? research? phone calls?). Allot enough funds and time to this pre-design phase.

The remaining sections in this chapter delve into each of these four pre-design steps—goals, message, audience and content—in turn, finishing up with a detailed discussion of site architecture.

What are the Goals of the Site?

For some sites, the goal is obvious. A retailer wants an e-commerce site to sell merchandise. A school wants to allow students to check homework assignments online. Or sometimes, simply, "Our customers keep asking us for our URL."

More often, the goals are ambiguous and unstated, but they want the site up yesterday. The designer blithely proceeds in creating a site based on whatever content is handed over.

This leads to unhappy situations. A client who you assumed just wanted a "brochure" site (because that's what they gave you for content), actually wanted a high-traffic site so they can sell banner ads. You only find that out when the site's been up for six months and they call to ask why their traffic is so low, and by the way, can you move the top navigation bar so they have room for their ads.

Another client calls and complains that they're being flooded with e-mail inquiries from completely unqualified prospects, informing you after the fact that the reason they wanted a Web site was to decrease the amount of administrative time spent on dealing with this type of people, not attract more like them.

If you had known these goals from the beginning, you would likely have designed the sites differently, as well as worked with the client in coming up with a different site structure and content offerings targeted towards the goals.

Start off the pre-design phase by making sure everyone is aware of and in agreement about the goals of the site. If it's hard for your client to come up with something specific, something beyond a generic "Provide access to our information twenty-four hours a day," try some brainstorming. A good starting point is to ask your client, "Let's say the site has been up for six months. What would indicate to you that the site is an astounding, 'break out the champagne' success?"

A response such as "When sales from our Web site meet or exceed those from our existing channels," will guide your development efforts towards one direction, whereas the reply "When we win the Cool Site of the Day award" tells you something entirely different. Try to get the client to tell you a number of goals, paying no attention to their relative importance at this point. Make sure you elicit feedback from everyone with a stake in the project: upper management, marketing and the IT department at a minimum.

Try to get the client to tell you a number of goals, paying no attention to their relative importance at this point.

GOALS

GEN	Communicate our educational philosophy
EVENTS	Share information about current school events
ADMISS	Increase admissions - more apps
DEVEL.	Promote fundraising activities (form?)
CURR.	Share classroom activities
CURR.	Provide curriculum info
CURR.	Allow students to check homework assign.
ALUM.	Alumni outreach — database, reunions
CURR.	Enhance access to teachers (e-mail links)
EVENTS	Encourage student club membership
TECH	Allow staff to update site easily
GEN	Encourage reuse of community:
	parents, teachers, staff, st...
GEN	Promote the concept of a program
CURR	Acknowledge successes of students
CURR	Provide a creative outlet for stu...
ADMIN	Make the application process e...
CURR	Provide access to past issues of...
DEVEL	Promote ongoing events (aquit...

A long wishlist of site goals gathered during a client meeting gets winnowed down to a more reasonable list of goals for the immediate "first phase" of development, and two more in the coming months.

Site Goals

SITE GOALS

Phase 1: Admissions Focus
Provide background information on the school
Introduce key personnel (principal, heads of each of the schools)
Describe educational philosophy (progressive education)
Detailed information about lower school, middle school, high school curricula
Explain admissions process, step-by-step
Provide admissions timetable, tuition figures, financial aid information
Provide a downloadable application (PDF)
Promote the existing community via pictures and "photo tours"
Note goals of Phase 2 and Phase 3

Phase 2: add School Community Focus
Provide sections for Alumni, Teachers, Staff, Parent Council, Development
Increase Alumni involvement via contact database, Alumni events and reunions
Provide a forum for parents to share ideas with each other, discuss school policies
Provide a complete list of faculty/staff bios, pix, and e-mail links
Provide departmental templates for teachers to create their own "mini-sites" with class projects and professional research/accomplishments
Connect the community to the Development Office and provide easy access to volunteer/giving opportunities
Note goals of Phase 3

Phase 3: add Daily Life Focus
Provide current information on student activities: clubs, athletics, plays, etc.
Promote special events, provide registration forms/ticket purchase
Enhance student involvement by turning over sub-sections to student Web Committee
Provide school calendar, weekly news
Add access to current and past issues of school publications
Keep students and parents up-to-date with Homework Hotline
Start up school e-zine/listserv

The following are some site goals that may help to spur further discussion with your client:

- Match/exceed what our competition's doing on the Internet
- Generate revenue from existing sources
- Create a new revenue stream
- Increase name/brand recognition
- Organize our marketing message
- Provide a one-stop source for a particular audience (the press, new users, vendors, etc.)
- Set ourselves up as the "expert" in our market by providing cutting-edge content/complete research material/most comprehensive list of linked resources/etc.
- Decrease administrative expenses (mailing out brochures, answering general queries, messengers, etc.)
- Win awards
- Reach/do business with international clients and prospects
- Launch a new service/product
- Make it easy for us to add/update new information
- Learn where our prospects are coming from
- Become a portal
- Sell subscriptions
- Convert from a print-based to an online-based publication
- Sell banner ads/participate in a banner ad exchange
- Provide a venue for our divisions/departments/regions to post their own "subsites"
- Make it easier for our customers to do business with us
- Offer online gift certificates and coupons
- Make it easier for field staff to gain up-to-date information
- Provide historical information or archival material

Once you have a healthy list of site goals, work through them with your client so you can rank them. What are the primary, immediate goals? What are the secondary goals?

At this point you may want to consider (if they haven't brought it up already) breaking up the site development into phases. This is critical for first-time Web clients who "want the moon" but have little idea how much work and expense is involved.

For example, Phase 1 for a retail site might include a home page (the main entry page), sections that present their marketing materials, a map to their store, and per-

Different messages for different audiences

These five Web sites, each belonging to a different company or organization, have their own particular message geared toward their target audiences.

California Casualty reaches out to current and prospective insurance customers with a clean, friendly corporate look.

Digital New York magazine is sophisticated and spare just like its Web site. Note the neat stack of navigation bars along the right side geared toward its disparate audiences: subscribers, advertisers and the East Coast creative community.

The trade group National Housewares Manufacturing Association (NHMA), organizers of the huge annual International Housewares Show, recently went through a re-branding of its Web site to set it up with its own, "stand-alone" identity, complete with its own logo ("housewares.org" at top center-right); the NHMA logo is to the right of that. Housewares.org must reach many different audiences with different agendas; these are reflected on their home page.

Print can't do justice to the Soundpunks.com Web site; you have to go there to hear the fascinating soundtrack synchronized with Macromedia Flash animation that is part of the "design message." Still, even the mute screen shot clearly conveys the message that this company is on the cutting edge of Web-based technology and design.

At the other end of the spectrum from Soundpunks.com, The Ritter Group Web site conveys a conservative, balanced and formal design message. The Ritter Group provides consulting services to companies who need representation for large, natural disaster-based insurance claims.

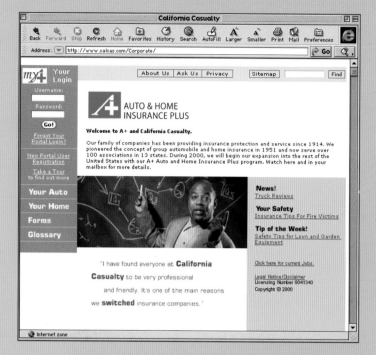

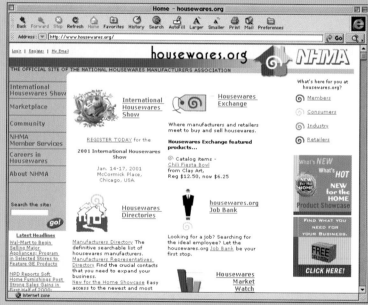

haps a form where people could request a catalog be mailed to them. Phase 2—to be completed three, six or twelve months down the road—would add e-commerce functions to the site: an online catalog, a shopping cart. Future phases could add a new line of products, downloadable manuals or parts lists, a bulletin board and so on.

What is the Design Message?

The goal of a car salesman is to sell you a car. Yet the way he dresses, how he introduces himself, even the inexpensive ballpoint pen he uses to fill out the paperwork, all serve to communicate that he's honest, professional, friendly and approachable. Wouldn't you feel more comfortable making a $25,000 purchase from this guy

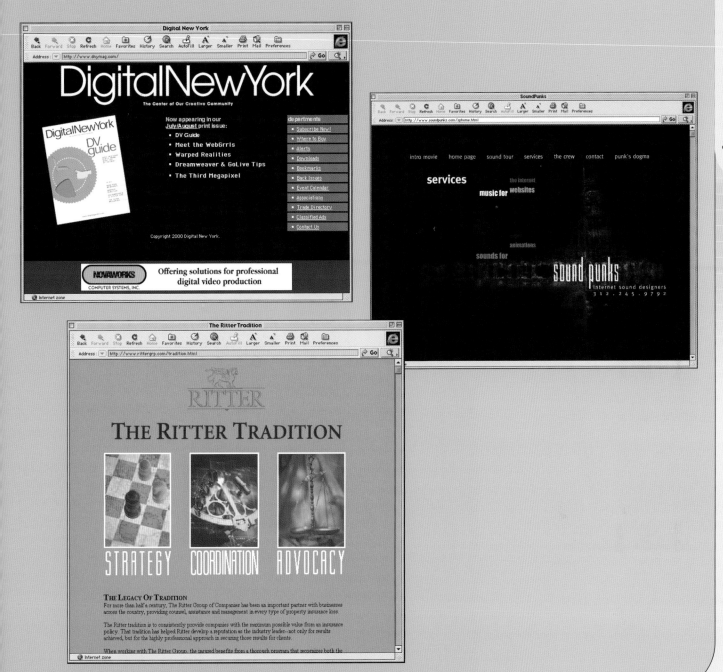

rather than the shifty-eyed, slovenly bum selling cars across the street—or the
snooty gaggle of three-piece-suiters in the high-priced lot around the corner?

The same thing is true about Web sites. Related to the site goals, and supporting
the site goals, is the overall message the client wants to convey about their organiza-
tion—one that sets them apart from their competition. Your duty is to help get the
message across by the look you create. It's what I call the design message.

The client might already have a design message that they employ in their letter-
head, on signage, on the sides of their truck. This is called their branding, also
known as corporate identity. Find out if the site needs to conform to any of their
existing brand identities. If so, you'll need the specifications for the colors, typefaces

and logo positioning, or at least some sample print pieces so you can winnow out the specs yourself. (Make sure your client understands that you can't match print specs exactly, since the Web is a different medium.)

In some cases, the client would like you to develop a new brand identity just for their site, which is exhilarating for most designers. In other cases, clients have no existing branding at all—not even a professional logo—and will ask you to create one for the site that they can use on their print pieces too. (You should consider breaking out the "for print" portion of this request into a separate project with its own quote.)

Even if they have a company "look" they want you to include in the site, you'll be creating new graphics and new layouts, so you still need to know the message behind the branding. How do you find out? Just ask. Pose the question during an opportune moment in one of the pre-design meetings: "What sort of image do you want your site to convey? What do you want the design to 'say' about your company or your service/products?"

Here are a few actual responses I've heard from clients:

1. We're a fun company. We don't take ourselves too seriously.
2. We're beyond hip—where we go, others follow.
3. The whole company is made up of computer geeks, so you can count on us to be the experts.
4. The company president is into the Buddhist culture and he would really like a "Zen" look. The site should say "peaceful."
5. This private school is sophisticated, progressive and, most of all, child-centered.
6. Our firm simplifies this complicated process for you. We make things easy.
7. Globetrotting, adventurous, exciting ports of call—that's us!

Some of these responses surprised our design team (I was glad I asked!), and all helped us immensely in coming up with various graphic approaches in tune with the client's desires.

Who is the Audience?

The main reason you need to know who the primary and secondary audiences for the site will be is so that you can design a site that is accessible to them.

If the primary audience is high school kids and their parents, they will probably be using analog modems (whose top speed is 53K) and less-than-current browsers. You can't make the site's look and feel hinge on HTML features that only work with the latest browser versions (more on that in chapter three) and expect these sites to be successful. Same thing with older audiences (say, for a health resources or hospi-

tal site) or college-age audiences, who are likely using the battered computer that came with their dorm room.

On the other hand, if the site caters to computing professionals, such as art directors, computer animators or network administrators, you can probably feel safe in using some big graphics and cutting-edge Web features, knowing that these users must stay current to be competitive.

So, how do you figure out the primary audience? The client's goals should tell you. Since they likely have multiple goals, they are probably trying to reach multiple audiences, and like the goals, some are more important than others.

A professional association is probably trying to reach their members, prospective members and students who are majoring in the field. A head-hunting firm is trying to reach both potential employers and job-seekers. A college wants to attract alumni, students, prospective students and their parents, and often also counts its professors and staff as likely site visitors.

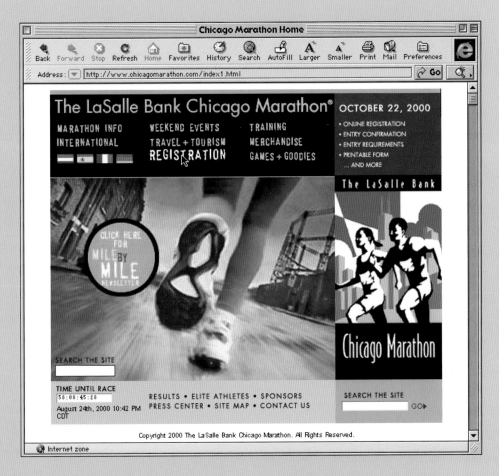

Runners who need information about the Chicago Marathon (sponsored by LaSalle Bank) are generally young and in a hurry. The site loads quickly and uses a lot of Flash animation and sound to keep their interest. Everything about the site is geared toward the audience, note the "Time Until Race" readout on the lower left.

World Book Encyclopedia is the inter-national best-selling encyclopedia for school-age children. It's quickly apparent from the bright colors and fun features that the site is geared toward kids, and more subtly, to their parents, teachers and school librarians.

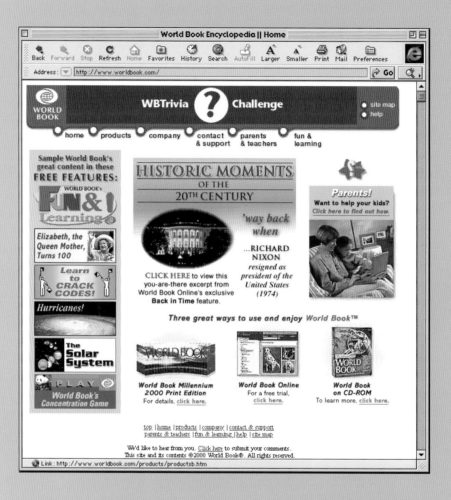

Confirm with your client who their primary audience is and ask if they have any data regarding the kinds of computers and software they are using. (It probably never occurred to them to ask, but it's worth a shot.)

If in doubt, always aim for the consumer-level user, and try not to leave anyone out. For instance, consider the use of Flash interface—the graphics, text, links and animations created in Macromedia Flash that allow users to interact with your site. If you want to use Flash, remember that the user will see the Flash effects only if he has downloaded and installed the company's free Flash plug-in or is using a late-model computer, which most likely has Flash pre-installed in its browser. So make sure you also provide an "un-Flashed" version of the site, and don't forget to include this extra work in your quote.

What and Where is the Content?

Now we're getting down to the nitty-gritty. You know what the site should accomplish and you know which group of users is most important to the client. Now you just need to know the scope of the site: Exactly what does the client want to include, and who's in charge of getting it to you?

Outline the contents

Start out by going over any sort of outline the client supplied to you, or create your own outline based on anything they've expressed should be included, filling it in based on the site goals and their input. The names of the categories or sections, and how pages are arranged within them, are preliminary at this point. You'll be firming this up in the next pre-design task, site architecture.

With your client, go over each main category, subcategory and individual page, and hammer down the specifics.

Say they want to put up old issues of their newsletters. Important questions to ask are:

1. How far back do they want to go?

2. How do they want it arranged (by issue, by topic)?

3. Would they prefer each article to appear on a separate page in HTML format, with a Table of Contents (TOC) page linked to them?

4. Or would they prefer all the articles for a given issue to appear on the same page, with links at the top?

5. Or do they just want a page with links to downloadable Portable Document Format files (PDFs) of each issue? PDFs are documents converted from their originating program's file type (.doc, .ai, etc.) to Adobe Acrobat's cross-platform document type (.pdf). They retain all original graphics, layout and fonts and are compressed for quick downloading.

As you work through the outline, you may come up with content ideas that hadn't occurred to the client. You're the Web professional—your input is part of the value you bring to the table—so suggest away!

For example, when discussing the newsletter archive, you might also ask if they want to put up their current newsletter. If so, would they like it to be spotlighted in a different section, or should you include the articles with the others? Would they like users to be able to click on a link or fill out a form to get on the newsletter mailing list?

Go through this questioning process for each item in the outline. Your aim here is to come up with a rough page count for each section, and an idea of the amount of

work involved in creating those pages. It should be close to your original estimate for the project. If it's not, now's the time to bring it up! If the scope is much larger than what you were counting on, it's an ideal time to propose breaking up the project into phases, as I discussed earlier in this chapter ("What are the Goals of the Site?").

Create Content List

The larger a site is, the more likely you'll find yourself inundated over the next few weeks or months with content elements being e-mailed, faxed and messengered to you, and not only from various staff members but often from the client's printer, photographer and other vendors. Establishing and maintaining control of all these content elements is the key to a smooth development process.

So let's do some organizing by setting up a Content List: a document that lists all the pieces of content that need to go into the site, with information regarding who's going to give them to you and by what date. Then if production is running behind because of missing content, you can point to the Content List and say, "Here's why we're late."

To create a Content List, make a table that includes every page of the site down the left-hand column, organized by your preliminary sections (remember, it's not set in stone at this point). Make sure there's enough room under each page name to include the types of content that will go into that page, and write those in. By "types" of content, I mean that any given page will contain content that is text, images and/or an interactive element (forms, search engines, surveys, guest books, etc.). Don't include navigation elements or headers and footers.

Sit down with your client and fill in the Content List (a bag of bagels and some orange juice helps). For each content element per page, discuss, agree and fill in the answers to the following:

• Does it exist? If not, who is responsible for creating it (taking the picture, writing the copy, gathering the list of staff e-mail addresses, etc.)?

• If it exists, is it in digital form? If not, who is responsible for digitizing it?

• If the content element is in the form of a text, database or page-layout document, do we have software that will open it? If not, who will convert it to a format we can access?

• When will we receive the element from the client?

• Who is in charge of getting it to us?

• If we're doing the digitizing, how long will it take us?

The end result should show not only a list of who's in charge of what, but also a final date signifying when each element will be in its final digitized format, ready to turn over to the Web production team.

Type up the final Content List and get your client to sign off on it. Then send a copy to everyone named within it (or post it on your project Web site, if you've created one), and keep your copy handy. It will be your touchstone throughout the entire project.

Note: A number of Web design firms approach bidding on larger projects in two phases. They provide a preliminary estimate for taking the project up to this point. Once they know the scope of the site, then they provide a second, separate estimate for the design and production phase.

Site Architecture

Every Web site has a home page. That's the easy part. The difficult part is deciding what links, buttons or areas on the home page's image map should exist. Where should they lead? What should they be named? And which links should appear on those subsequent pages, leading users deeper into the site, as well as back up the hierarchy?

PAGE/CATEGORY	PAGE CONTENT (Approx. word count for short description/long description)	HAVE ALL (OK)	NEED TEXT	NEED PICT.	WHO/WHEN
Home Page	Introductory Copy (150)		x	x	
	Specials (which products?) and text (20 ea.)		x	—	
	Other sections, if desired (news, etc.)		x	—	
Products for Sale		—	—	—	
Popular Packages	Which? Text (20) and pic		x	x	
Gift Certificates	Text and pic		x	x	
Live Lobsters					
	Lobster Gram Deluxe (50/200) and pict.		x	ok	
	Lobster Gram (50/200) and pict.		x	x	
	Just the Lobsters (50/200) and pict.		x	ok	
	Summary of other products for sale within this category that aren't available on the site		x	—	
Lobster Tails					
	Caribbean Tails (50/200) and pict.		x	x	
	Maine Tails (50/200) and pict.		x	x	
	Tail Sampler (50/200) and pict.		x	ok	
	Down Under Sampler (50/200) and pict.		x	x	
	Summary of other products for sale within this category that aren't available on the site		x	—	
Surf & Turf					
(this also goes in LL sect)	LG Deluxe Surf & Turf (50/200) and pict.		x	ok	
(this also goes in LL sect)	LG Surf & Turf (50/200) and pict.		x	x	
	Caribbean Tails/Turf (50/200) and pict.		x	x	
"stock special"? looks like a surf and turf	Maine Tails/Turf (50/200) and pict.s		x	x	
"tailturfct"? group photo of Tails/Turf	Summary of other products for sale within this category that aren't available on the site		x	—	
Amazing Combinations					
(this also goes in LL sect)	New England Prime Dlx (50/200) and pict.		x	ok	
(this also goes in ST sect)	Maine Marvel Dlx (50/200) and pict.		x	ok	
(this also goes in LL sect.)	Crustacean Sensation Dlx (50/200) and pict.		x	ok	
(this also goes in LL sect.)	Boston Party Gram (50/200) and pict.		x	ok	
	Shrimp Cocktail (50/200) and pict.		x	ok	
	Summary of other products for sale within this category that aren't available on the site		x	—	
Crab Heaven					
	Summary of other products for sale within this category that aren't available on the site		x	—	

The Content List drawn up for the first phase of the Livelob Web site (see home page screen shot on page 17) helped keep the client and the design team on track during weeks of production. It also helps the client realize the scope of new content that often needs to be written for a Web site; regardless of the number of brochures, catalogs and newsletters they might repurpose.

How to present a site architecture

It's critical to acheive a consensus with your client and the design team on the site architecture before you proceed to the design phase. How can you design a navigation scheme for the home page and section pages if you don't know how many levels there will be and how many links are in each level? Approach this presentation as you would a design presentation and be prepared to go through a number of modifcation rounds until everyone's happy.

For smaller, simpler sites, often an outline is sufficient (right). Larger sites do well with a flow chart like the one on page 43 (this one lacks arrows show- ing the linking strategy, something your client may need to see). Full-fledged storyboards may help a client visualize a larger site (bottom).

Try to keep everything simple and stark at this point; you're trying to evaluate the "skeleton" of the site, not the pretty make-up.

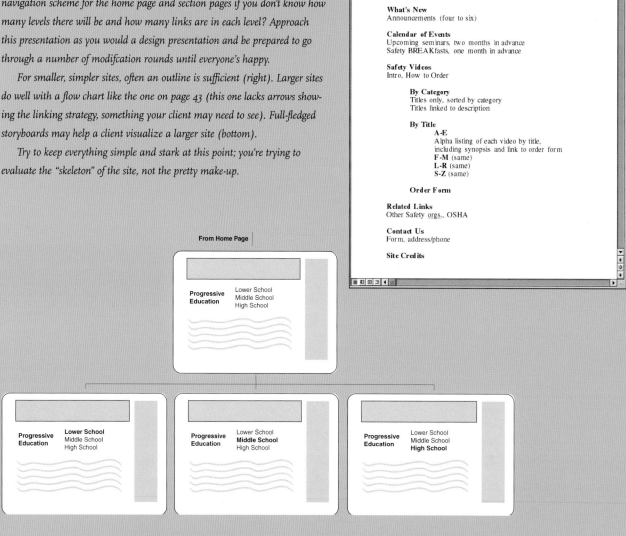

Let's say for argument's sake that the entire site consists of fifty HTML files (pages), plus the home page. Few Web designers would opt for creating fifty hyper- links to each of those pages from the home page. Similarly, almost no one would choose to provide only a single link leading to a different page (and on that page, one link leading to the next page, until forty-eight clicks later, you're at "the end").

The trick is finding the optimal point between these two extremes. Site architec- ture is the art of strategically grouping the site content into navigable sections that would make the most sense to the site's audience as well as encourage or help them do things that satisfy the client's goals. You want the site structure to help, not hinder, its functionality.

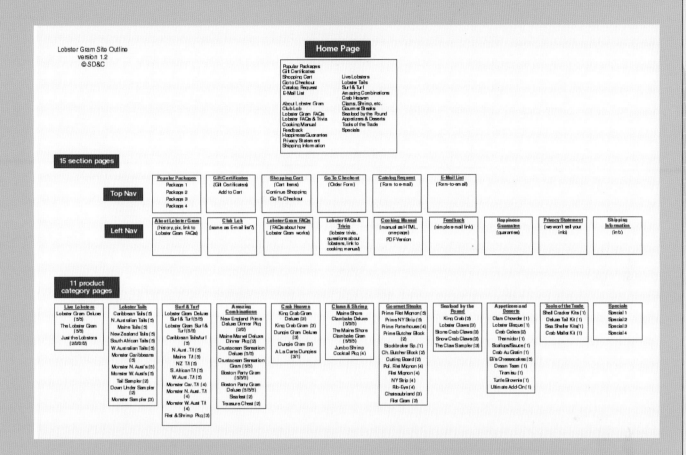

Plan an efficient linking structure

The site goals are a good place to start. The more important the goal, the easier it should be to accomplish. If the client wants the site to sell products, then you should try your best to arrange the site so that products can be viewed and purchased with a minimum of drill-down, or clicking to deeper and deeper layers in the site hierarchy. Placing them right after the home page at the second level is best, but no deeper than the fourth level. Including a few products right on the home page (in a right-column "New" or "Site Specials" area, for example) can only help.

When you're structuring the flow of a site, you have to rid yourself of preconceptions. Don't start from the outline that you used for the Content List and modify from there. The Content List was only for managing the site development.

The Joyce Foundation site architecture is based on the various audiences it is targeting and what they will be looking for when they arrive at the home page. Grant seekers are interested in application guidelines, policymakers are looking for background information on programs, the media needs quick access to press releases.

Start from the perspective of a typical user, a member of one of the client's primary audiences. Think: You're at this organization's home page. As an interested user, what would you hope to find easily accessible? What would compel you to explore the site further? What would keep you there? Do you assume any sections or specific pages will be there, based on other sites in the same market niche?

Go back to the example of the selling site. You and your client may have worked up the site's Content List based on sections for each regional location: West, East, North and South. For each section you have products, sell sheets and staff information. As a customer, would you care about the e-mail address for the vice president of marketing for the Western region? Probably not. You want to know what the site is selling, and for how much. Instead of home page links leading to West, East, North and South, it would make more sense for them to lead you to product categories: Boots, Sandals, Dress Shoes. If certain items are only available in certain regions, you can provide regional links deeper in the site and/or offer a "product finder by region" page.

Let's take another example: a software developer's site. Besides selling the product and providing the media with handy access to press releases, a primary goal of our client is customer support. They want to decrease their tech support department's workload and expense by putting as much of the support information up on their Web site as possible.

Pretend you're a user of the product who tried calling the tech support number and got a voice mail message suggesting you try the Web site. Here you are at the home page. What do you expect to find?

A big fat link that says "Support," of course! The link shouldn't be buried in the Current Customer or Info section, even if that's where it exists in the site structure. It's a primary goal, so make it easy to achieve.

After clicking the Support link, what do you want to see on the Support section page? From my own vast experience flailing away at obnoxious software, I have a refined taste in support sites. What I expect to find, first of all, is a FAQ—the Internet jargon term for Frequently Asked Questions. It's a good day when my particular problem has been asked and answered in a company's FAQ. I would also expect a link to a list of product updates and bug fixes. A nice surprise would be a link to download the latest product manual in PDF format.

When you were creating the Content List, perhaps you listed "PDF manual" under the Publications section, and Product Updates as a main link off the home page. There's nothing stopping you from maintaining that hierarchy if you still think that's the most logical way to organize things, but by all means also include links to those items in the Support section. Go ahead and duplicate a link, or several links, in different places if it makes sense; you won't be arrested.

You simply can't count on the users to learn the entire site hierarchy after casual use. Hapless souls in the Support section will not remember that the Product Updates link is on the home page; they'll be looking for it in the Support section. Make it easy for the users to do what's logical for them at any given point, even if it doesn't conform to the site hierarchy.

Of course, there's such a thing as going too far. One of the great debates in Web design is how much of the site hierarchy should be offered as a link on a given interior page. If a site has five sections, and each of these has five pages belonging to the section, should each of these third-level pages contain links to the other four pages in the section? Is it reasonable to expect people to use the Back button to go back to the section page, and from there link to the other pages? Should you include links to the other sections in these pages?

You don't want to overwhelm the user with links, but you also want to reduce the number of times a user has to click to reach a particular page. It's a balancing act.

The only hard-and-fast rule is to include a link to the home page on every page in the site, in case the user wants to "start over."

If you want to learn more about information design strategies for Web sites and beyond—it's a huge and interesting field of study—take a look at the Web sites and publications listed in the Appendix.

Create a flowchart

Now that you've decided on the best way to structure the site, present it to your client. Designers do this in different ways, depending on their resources, the complexity of the site, and what the client is expecting to see. (For the remainder of this section, refer to the illustrations on pages 42 and 43 for flowchart style.) At the least, you'll provide them with a new outline of the site, and after each page name, include a list of navigation links (with the actual text you might use, like "Home, Support, Shipping Information" etc.) that will appear on that page.

You can take the middle road and create something that looks like an organization chart. Draw a series of boxes in an illustration or page-layout program, each box representing a single page, each row of boxes representing a single layer (roughly pyramidal in shape, with the home page at the top). Type the name of the page inside the box, and draw arrows to other boxes to show how they would link. Don't forget to name the links.

You can go all out and do it "storyboard" style, as ad agencies present commercials. Each "frame" on the storyboard represents a miniature Web page. Each storyboard would contain either one hierarchical level of pages or one whole section drilled all the way down. I would caution you to make sure the look of the miniature Web pages is as generic as possible; if you must include a representation of the navigation links, a row or column of rectangular buttons will do for now. You don't want the client to get hung up on the design of the pages or the background colors or anything, since you haven't started the design phase yet.

During your presentation you will, of course, describe the strategic thinking that led you to this particular site structure, especially if it veers markedly from the preliminary site outline. The client will usually have some feedback, sometimes surprising ("our audience would never do that/want to go there/wouldn't need that because yadda, yadda . . ."). This is welcome information, because it's a lot easier to make structural changes now, when nothing's been designed yet. Make a note of it and move on.

Don't be surprised if the client suddenly realizes that the site is either missing some vital content ("I can't believe we forgot that we wanted to include a photo tour

of our new building") or that some existing content can't go up after all ("The security director doesn't want us to put up our staff list"). Again, this is great news! Because it's far better to learn this information now than later, when you might need to redesign the site to accommodate the changes in content.

During the presentation, double check with your client that the text labels you're using for the links to other pages are acceptable (e.g., do they prefer "Press Room" or "Media Packet" for the section with the press releases?). You will be using those when you design the site, so you might as well get approval for as many of them as possible. (These are somewhat easier to modify during design and production, so don't worry if they need to "think about it" for a few days.)

If you're lucky, the client has little or nothing to add, other than "Great job!" since you've thought of everything. More often, they have moderate changes they'd like to see, and sometimes they're major enough so that the best course of action is to literally go back to the drawing board and devise a new site structure (and new Content List, if warranted). Proofing rounds continue in the usual manner until the client gives their final approval.

Now—finally—you can get to work on the design phase, which I cover in the next chapter. Since you've accomplished all the preliminary content and structure steps, you can be confident that the look you'll be creating will work for the site.

```
function changeto1()   {
document.layers["text"].document.write("<fo
nt color=blue><a
href=http://www.urlhere.com>Link
</a></font>");
      )e(;
```

```
<head>

<script language="JavaScript1.2">

function changeto1(){
setTimeout(changeto1,   "1");

function changeto1()   {
document.layers["text"].document.write("<font
color=blue><a
href=http://www.urlhere.com>Link
</a></font>");
```

a design that works

Desperately Seeking Synthesis

If you're a professional graphic designer, at this point you're probably muttering, "Enough with the preliminaries. When can I start designing?" But I'm sure you can see that you have been designing all along, just not yet in the traditional "graphic design" sense. You've helped your client to design site goals and content strategies, and you tapped your creative sensibilities to design the information flow in the site architecture phase.

Stick with me. You'll receive the go-ahead shortly to start slinging pixels. First I want to go over some overall ground rules, and I'll cover the specific rules in the following section.

For the Web graphic designer, the task at hand is to create the look and feel for how the content of a Web site is presented to the end user. The design must support and account for all the preliminary work done thus far—it must achieve synthesis with the site's goals, audience and structure, and convey the message the client has specified. You want visitors to be presented with a unified whole when they visit the site; The design "makes sense" and "feels natural" for the site as a whole, and if pressed, few visitors could conceive of any other more appropriate design for this site than what they've seen already.

The design must support and account for all the preliminary work done thus far—it must achieve synthesis with the site's goals, audience and structure, and convey the message the client has specified.

Seasoned print designers are familiar with what I'm talking about, since they go through the same thinking process when they're developing a design for a brochure, annual report or mail-order catalog.

But for you Web developers without a design background, here's an analogy. Think of what image consultants advise clients about choosing an outfit for an important occasion. They say that when people see you in the attire you've chosen, you don't want to be remembered for the particular dress or suit you were wearing, but you want people to be impressed by the person wearing the dress or suit. Wearing an outfit appropriate to the occasion without a lot of inappropriate gewgaws or awkward creases and bulges will help that occur.

Of course, sometimes the goal is to shock by presenting yourself as an easily identifiable "maverick" or by defying people's preconceptions. This strategy can be just as effective when translated to Web design, assuming that's the sort of message the client wants to convey.

By the way, if you are not the actual designer, at this point you'll turn over the signed-off site architecture document to the designer. If he or she doesn't already know the ground rules I discuss here, go over them. Also be sure to review your specific requirements with the designer—the site's goals, design message, audience and any special content-related issues—if he or she is just joining up with you now.

Web Design Guidelines: Caution! Falling Pixels Ahead

This section covers a general graphic design guideline for Web design beginners and for print designers making the leap into this new medium. Detailed instructions about HTML, Cascading Style Sheets, Flash, JavaScript and getting those GIFs to jump around can be found in many other great books. You should definitely pick up a few! Even though I've been designing Web sites since 1995, when I'm working on a site I'm invariably surrounded by three or four of these open to different chapters. I list my favorite books and other resources in the Appendix.

The first Web page designs you will be showing your client, unless you're a sucker for punishment, will be prototypes—models that look like a Web page but aren't—created in an illustration program. Typically, designers create these pages in Photoshop, but I've also seen them done in Adobe Illustrator, CorelDraw, FireWorks, Altsys FreeHand and even QuarkXPress.

It's best not to jump right in and present to the client "real" Web pages. "Real" Web pages mean that they've either been 1) hand-coded in a word processor or 2) created in a Web-authoring program—an application that helps users to create sites by automating much of the production process and the hand-coding of HTML tags—such as Adobe GoLive or Macromedia DreamWeaver. So why not present the

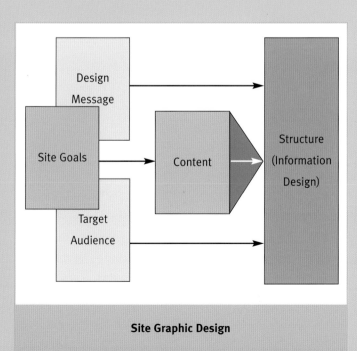

Site Graphic Design

Achieving Synthesis

The graphic design of a site needs to take into account everything that preceded it....

> *Site Goals*
>
> *Design Message*
>
> *Target Audience*
>
> *Content*
>
> *Site Architecture*

...while still adhering to the site design parameters as explained in the Web Design Guidelines section.

The need to combine marketing expertise and information design techniques with a fine-tuned graphic sensibility is what makes the field of Web site design so challenging and rewarding.

The history of HTML

You can go to the World Wide Web Consortium Web site and look up the "official" specifications for HTML tags dating back to 1994. As of this writing the latest Web browsers are supposed to be supporting HTML 4 specifications (top), but to build sites that reach the largest audiences, you should probably keep the ones from the previous version, HTML 3.2, most of which still exist in HTML 4.

"real" stuff? Because in the design proofing stage, it makes sense to allocate the bulk of your time to the design process, not the production process. Unless you're working on an extremely simple Web site, changing the layout, colors or button text of actual working Web pages can be a bottomless pit of tedious production hours.

So the best course of action is to work through the first rounds of design presentations and modifications with "for looks only" prototypes, and save the HTML conversion until the last (hopefully) or second-to-last (more likely) presentation.

I discuss Web design presentation strategies in more depth in an upcoming section ("Site Design Presentation Process" on page 69). At this point, be aware of the inherent danger of designing Web page prototypes in an illustration program: It's easy to inadvertently include something in your design—special formatting here, an interesting graphic effect there—that cannot be reproduced in HTML. Or maybe it

Why all the Confusion?

New Web designers, especially those coming from the print world, are often chagrined when they first learn of the need to plan and compensate for browser and platform differences. How did we arrive at this state of affairs? And what can we do about it?

The beginning of HTML

The Web was never meant to be a venue for graphic designers to strut their stuff. From the start, it was meant to be a way for scientists and researchers around the world to share their findings with each other without having to wait for them to be published in a professional journal. If an ASCII text file was put on a Web server, anyone with a Web browser and an Internet connection could view it, regardless of the type of computer they used or which fonts they had installed. Also known as "plain text," ASCII (American Standard Code for Information Interchange) is the basic set of characters used by almost all computers. It is made up of unaccented upper and lower case letters, numbers, the space, some control codes (like the carriage return) and most basic punctuation.

A Web page author could spice up the formatting of the plain text by adding a few HTML tags that the browsers were programmed to interpret: "There's a before the word? Oh, that means show the word in boldface." The slickest tag by far was the one that created hypertext out of a word or phrase. Hypertext is text linked through the use of HTML codes so that clicking on it directs the browser to a different location on the page or to another page entirely. A browser interprets the tag to create an underlined link, and it knows that if a user clicks the link, it should replace the current document with a different one.

That's why it's called HTML: Hypertext Mark-up Language, nothing more.

HTML version 2

A little later, the volunteer geeks who'd taken on the task of being the "gatekeepers" for HTML specifications decided to add more tags, and this new set of tags was introduced as *HTML version 2*. The first browsers needed to be reprogrammed so they could interpret the new tags, obediently showing the graphics when called for in the ASCII text. Users had to upgrade to the new browser version if they wanted to see those graphics—without an upgrade, they'd just see the actual tags, if anything. (*Continued on page 54*.)

can, but only after a ridiculous number of production hours. Or maybe only the elite 10 percent of your audience with the newest browsers would be able to see it, and you'll have to do another version for the great unwashed.

The versions evolve

Then corporate America, who at this time had been paying big bucks to America Online, Prodigy or CompuServe for the privilege of setting up their own online "community," got a gander at Web sites with text, graphics and hyperlinks, and all hell broke loose. Why pay a private company to put up an online corporate hangout that was only accessible to its own members, when they could create one that was accessible to the entire world virtually for free?

They sicced their graphic design teams on the task. Intrepid designers looked at the meager tags they could use and bent some of them to their will. The most well-known example of this is how designers to this day use table tags, originally meant for tables of scientific data, to create side-by-side columns for page layout.

The World Wide Web Consortium (W3C)—what the volunteer HTML gatekeepers now call themselves—and the major browser software companies (Netscape and Microsoft) have been fighting for position as "lead dog" in HTML standards-setting ever since.

It's true that the W3C is technically in that position. They have developed, tested and freely published their official specifications for HTML 3.2 (1996), HTML 4.0 (1997), HTML 4.01 (1999) and the current version as of this writing, XHTML 1.0 (2000). The browser developers are supposed to keep up with the W3C specifications: Version 3 browsers should support HTML v3.2 and prior tags, and version 4 and 5 browsers should support HTML v4.x as well as—to a great extent—prior specifications.

But those browsers developed by Netscape and Microsoft seldom support all the W3C specifications for a given release. They also have a bad habit of introducing their own formatting tags (HTML codes) with every upgrade of their browser software—tags that designers might love but nonetheless are not a part of W3C specifications. So these tags are seldom supported by their competitors. One example is the "hover" tag (it makes a word change its color when the user's cursor rolls over it), which works only in Microsoft's browser.

The companies are hoping that their proprietary code will become so popular that 1) Web designers will want to use it, and start to design for the browser ("This site is best viewed with Internet Explorer"), and 2) the W3C will include the new tag(s) in its next official specification of HTML—which has happened in the past—meaning the companies' competitors will have to hurriedly add that tag to the next release of their browser.

The W3C frowns on that, of course, as do a growing number of designers who just want one standard to guide their design. Unfortunately, this is the current state of things: not only do designers have to create Web sites that must work with the different HTML versions

that users' browsers are capable of interpreting; but they have to be familiar with how browsers that are at the same version may interpret the code differently, depending on whose browser it is and which computing platform it's running on.

How to Cope

Designers can employ a few different strategies:

1.

One strategy, called "the lowest common denominator" approach, is the one most in keeping with the original intent of the first Web developers, whose main intent was accessibility, not design. These designers limit themselves to features accessible by the vast majority of browsers and platforms in use by their audience. If you're not sure what that is, these days a "general Internet audience" is assumed to be using HTML 3.2-savvy browsers or later. You need to keep an extra eye toward the AOL v3, 4, and 5 browsers, though, because they have some peculiarities even with standard HTML v3.2 tags, and there are over fifty million AOL accounts out there. If the designer does employ a v4 or later feature, such as Cascading Style Sheets, it has to elegantly degrade, meaning visitors with earlier browsers will still see a nice-looking, understandable page even if the unknown tag is ignored or botched up.

2.

Another approach is to take the lead and develop a site using all the latest v4 and XHTML 1.x tags, reasoning that "Our audience is cutting edge and expects our site to be as well. For users who don't have the latest software, our content is so compelling and the design—which can only be achieved with these tags—is so slick that users will upgrade their browser if necessary to access the site." Frequently these sites will also have content in Flash, PDFs and QuickTime format, all features requiring an add-on plug-in to the browser software. Since most people with the latest browsers also already have these plug-ins installed, the same reasoning applies.

3.

Finally, as always, there is a middle ground. Since the percentage of users limited to version 3 browsers grows smaller every day, many designers choose to assume that their "lowest common denominator" users are on version 4 browsers. However, to gain some control over the process, they make sure that the HTML v4-specific features they use are limited to the relatively small subset that are supported by both Netscape v4 and Internet Explorer v4, on both the Windows and the Macintosh platforms. (I have a couple links to Web pages that list these in the Appendix.) (*Continued on page 56.*)

If the designer does employ a v4 or later feature, it has to elegantly degrade, meaning visitors with earlier browsers will still see a nice-looking, understandable page even if the unknown tag is ignored or botched up.

(*Continued from previous page.*) If the particular HTML v4 or XHTML 1.X-only tag does not elegantly degrade for earlier version browsers (such as layered elements), or if designers are compelled to use a feature that only works on one platform or browser, then they employ a browser detect/redirect script—a bit of JavaScript that's inserted into the header of a Web page where it's unseen by surfers. This popular script (most Web-authoring programs have a pre-built one that you can drop in as needed) can figure out which browser version a user has and can automatically redirect the software to load a different page URL that's optimized for that browser version. It happens so quickly that the user is unaware he is looking at a different page.

What this means is that for at least some of your Web files, you will have to create two versions (and sometimes more) of the same page, optimized for different audiences. It's extra work, but this method is widely employed because it allows the designer to push the envelope without locking out any users. In fact, designers will likely get to know the detect/redirect script very well, as the types of access to the Web grow in number and variation—Web TV, cell phones, PDAs, stand-alone "Web kiosks" at airports, even "smart" refrigerators, each with its proprietary Web browser and rules of engagement.

It's always a good idea to keep at least your home page accessible to the widest possible audience. You can put any instructions regarding which browsers are best for the site there, as a warning. (Note that most designers try to use browser detect scripts instead—users really hate to be told they need to upgrade.)

Among professional Web designers, the standard operating procedure is to always test Web page designs in the current version and one version back of the three major browsers: Netscape, Internet Explorer and America Online (which has a proprietary browser). Multiply that by two computer platforms (Mac and Windows) and that's 12 browsers all together! (And if you've got my luck, your client will complain that the site "didn't look right" when they dialed in from their home computer with their trusty copy of AOL v2. It's happened to me more than twice!)

You can keep multiple versions of multiple browsers on the same hard drive to some extent, or spread them among two or three computers in your office. Or you can just ask colleagues to please do a "site check" with the version you're missing but that they have. This type of request pops up every day on the Web design mailing lists I subscribe to. (See the Appendix for subscription instructions).

Think Ahead: What to Consider While You Develop Your Design

The trick, then, while designing a Web page in a non-Web program is to always be thinking ahead to the production phase. "I want to do X. Can X be reproduced in the HTML tags my audience can read?" It's slow going at first, but the think-ahead mindset will become second nature as you acquire more Web sites under your belt.

Let me cover some of the most common think-ahead situations you'll run into. These assume you are trying to create a site that is accessible to the vast majority of Web site users, meaning people who use v3 or a later version of their browser software. (See the sidebar, "Why all the Confusion?" starting on page 53 if you're not sure why the version of the browser used by your audience affects your design.) If you're designing a site for an intranet—one that's restricted to a company's employees—then you'll probably have greater leeway because you'll know at the outset which browser and version they use, and on what platform.

Think Ahead: layout

Probably the most basic thing to keep in mind is that every Web page has two layers: background and foreground.

The background layer is static. Users can't select it, Web authors can't manipulate it (turn it into an image map, for example). The background can be a flat color of your choosing, and it can contain a GIF or a JPEG image. If the image is smaller than the browser window, the browser will tile it. When you tile an image, you fill a browser window with repeated copies of that image. Background colors and images bleed on all four sides (i.e., they run right up to the edge of the window). If you don't specify a certain background color, the browser will use its default background color of 50 percent gray, or whatever the user has set in their Preferences. You can use a different background color and image on each page of a Web site if you want, they're page-specific.

The foreground layer is where the action is. Floating on top of the background, the foreground is a single functional layer consisting of text and rectangular graphics that lie next to each other. A single layer means no overlaps, not even a little bit. That means you can't put one graphic on top of another in the foreground; you can't screen back a graphic behind a block of text; you can't wrap text inside an arc (everything's rectangular, remember); and a whole ton of things that you might take for granted—especially if you're a print designer. Of course you can do all these things in your prototype, but you need to think ahead. Will you be able to flatten these

In addition to (or instead of) a background color, you can specify a single background graphic (JPEG or GIF only). If you specify both the background color will appear first, then the picture, and finally the text and graphics in your Body section.

If a background graphic is smaller than the window size it will tile (repeat) across and down the Web page. To prevent this you can create a background graphic that is larger than most window sizes, as has been done for the Joyce Foundation home page. In this case the background image is a 72dpi GIF that is 1700 pixels wide and 1700 pixels deep. The top screen shows just the background image, the second one shows the entire home page.

Background images are specified in the <BODY> tag of the HTML file, just as the background color is.

layers and cut them apart into rectangles? Then reassemble them in a Web-authoring program (probably using table cells to control the layout)? Or could you use some other trick entirely, so the HTML version will look about the same?

When I tell students this, they often say, "But look at this site I found! They're using rounded corner rectangles behind these head shots and the text follows this arc here and blah blah blah..." No, Virginia, the site designer has not discovered a secret HTML tag. If you look closely at these special effects (try dragging the graphics off the page to see their ghosted outlines) you'll see that each rounded corner is actually a separate image. This image is a rectangular Graphic Image Format (GIF) of an arc against a background color that matches the background of the page. You'll see that the "behind" graphic is actually a contrasting table background color or is a clever background. The text that follows the arc is not "live" text; it's text that's been converted into a GIF along with the arc artwork.

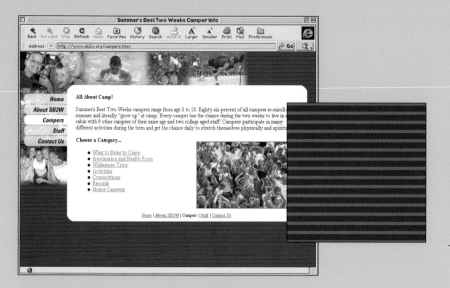

With a little forethought, a small background image can create impressive effects when it gets tiled across the screen. Here a simple series of horizontal lines on a blue background appears as a subtle texture when tiled. The designer also specified the dark background blue of the image to be the background color for the Web page.

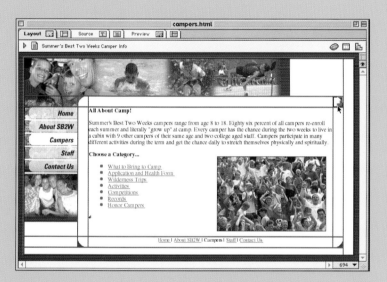

Creating a "layered" effect

Creative use of tables and sliced images can make an HTML 3.2-compliant Web page look like it's using HTML 4 features, such as layers. I've opened up this Web page in my authoring program and edited the table (extended the table's white background color to all its cells and changed its borders from "0" to "2" pixels) so you can see how the designer achieved the effect of a rounded-corner rectangle floating on top of an image.

Note that the photo montage, the rollover navigation buttons and the rounded corners surrounding the live text are all sliced images arranged in table cells. I've selected one of the "rounded rectangles" in the upper right corner so you can see that it's actually a single graphic image that's part white and part of the same tiled blue background.

On the other hand, maybe the student has landed on a "high end" page because they're using a v4 or later browser. A new set of tags introduced in HTML 4, called DHTML (D for dynamic), allows designers to create layered elements that can overlap, and even move around the screen, appear and disappear in response to a mouse click, and other fun stuff.

One fantastic thing about the Web is that it's open source—anyone can "peek behind the curtain" to see how the page was constructed. When you find a Web page that has some interesting effects, just go to your browser's View Source menu to see the HTML used to produce the page. There you'll find if the designer used a table, frames, an image map, DHTML or who knows what else to create the end result. And there's nothing stopping you from copying/pasting that HTML to your program for further study and using the same technique. (Just don't copy all the source code wholesale; it's not kosher.)

Transparent GIFs

The small navigation bar on top of this designer's site is actually a single GIF image that's been made into an "image map" with hot spots. Note as I drag the image that you can see the surrounding color that was made transparent. I often do test-drags of images on Web sites when I'm trying to figure out how they acheived a particular effect.

Think Ahead: images

All Web graphics have a resolution of 72 pixels per inch (ppi, aka dpi) and are in GIF or JPEG format. Since GIF images are limited to a 256-color palette, this format is best for images with flat colors, like logos, incidental artwork, and navigation panels. JPEG images don't have the color restriction. For this reason, they're best for contone (continuous tone) images—grayscale or full-color images that haven't been converted for printing purposes—like scans of photos or graphics with subtle shading and color gradations.

So why use GIFs at all, considering its palette restriction? First, the GIF format is the only one that supports transparency—you can optionally select one specific color to be transparent in your GIF image. That way, many images appear to be "silhou-etted" or have an irregular border on Web pages, even though you know it has to be square-cut and the background color of the image was set to be transparent. Second, the GIF format is the only one of the two that can support animation, which is a series of different GIFs compressed into one image file. There are other reasons why GIFs are used but these are the two big ones.

When you find a Web page that has some interesting effects, just go to your browser's View Source menu to see the HTML used to produce the page.

Think Ahead: text

There are two kinds of text you see on Web pages: live text and graphic text. You know it's live text when you can select it with your cursor and copy and paste the text into your word processor. Text that's been converted to a graphic (using an illustration program's text tool) is static, nonselectable and all of one piece, since it's a graphic. When you're designing a prototype, you need to think ahead if the text you're adding to the design will ultimately be live or not.

If it's going to be live, know that you will have little control over its formatting. Live text appears in the user's default typeface, typically Times, at the default size (12 point on Macs, 16 point on Windows), with default leading (space between

successive lines of text) that is about 120 percent of the point size. It will run from the left side of the browser window all the way to the right edge (at the vertical scroll bar) and then wrap to the next line. If users resize their window, it will rewrap to fit. To force the text to stop wrapping and begin the next line at the left again, you can either add a carriage return, which always adds an extra blank line in between the two paragraphs, or you can add a line break (a "soft return") which doesn't add the blank space but doesn't start a new paragraph either.

Anyone with Internet Explorer installed on their computer has these fonts available to them (even if they're using Netscape), so it's okay to specify them as the font for your live Web text.

I've set all these text blurbs at 16 point because that's generally the default type size for fonts on Windows and Mac IE v5. Be sure to turn off Anti-Aliasing in the Photoshop Type dialog box so your prototype closely matches how text will actually look in a Web browser.

This is frustrating if you want to apply a different paragraph format to the new line, like making it centered instead of left-aligned, but you don't want a blank line above it. Did I say frustrating? I meant impossible—unless you use Cascading Style Sheets, a v4-only feature.

Other text restrictions: There are no tab stops, no first-line indents, no indents at all, for that matter. Space runs and carriage return runs are ignored—no more than two in a row will appear, regardless of how many you enter.

Now it's not all that bad. You can specify the width of an empty table cell, and any text pasted or typed in the cell will wrap to its boundaries. By laying out your page into multiple table cells, and setting a "0" width table border, you will have a lot of control over column widths without anyone knowing it's all in a table (except for other Web designers).

You can specify a different font in the HTML font tag, and if users have the font installed on their computer, it'll appear in that face. (I'll never forget the first time I saw a Web site done entirely with the Futura font family. Very cool. Glad I had Futura installed!) If they don't have your specific font it will degrade gracefully to the users' default font. Most users have at least Helvetica (Mac) or Arial (PCs)

Live text appears in the user's default typeface, typically Times, at the default size (12 point on Macs, 16 point on Windows), with default leading (space between successive lines of text) that is about 120 percent of the point size.

There's nothing preventing you from specifying a font other than the regular Internet Explorer ones; it's just that visitors won't see the text in that font if they don't happen to have that font installed and available on their system. It was a nice surprise to come across this site where the text appears to me as Garamond (I don't have Tempus Sans ITC, the designer's first choice). You can see how he specified the fonts in this shot of the source code.

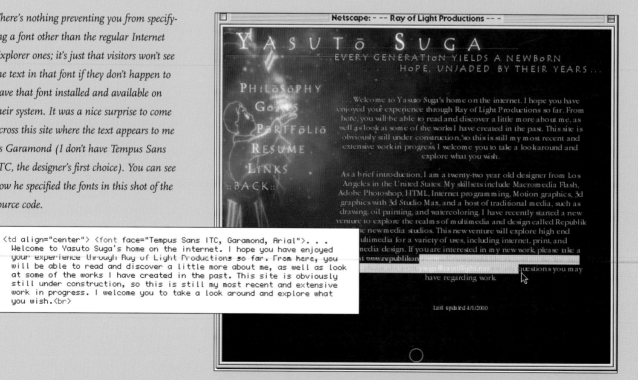

```
<td align="center"> <font face="Tempus Sans ITC, Garamond, Arial">. . .
Welcome to Yasuto Suga's home on the internet. I hope you have enjoyed
your experience through Ray of Light Productions so far. From here, you
will be able to read and discover a little more about me, as well as look
at some of the works I have created in the past. This site is obviously
still under construction, so this is still my most recent and extensive
work in progress. I welcome you to take a look around and explore what
you wish.<br>
```

installed, so if you like the sans serif look, feel free to reflect that in your prototype's body text.

You can also specify a different size for the live text, as long as it's one of the seven HTML font sizes. The default size is "3," so you can go two sizes lower and four sizes higher. You can make paragraphs left-, right-, or center-aligned. Text can wrap around a graphic (a rectangular wrap only, even if it's a transparent GIF). You

What About Style Sheets?

If reading about the limitations you have over how text looks in a browser is already driving you crazy, relax. Remember that I'm talking about creating Web pages for a "lowest common denominator" audience of folks who use v3 browsers. Most Web site audiences are at v4 or above. For these users, you can use CSS (Cascading Style Sheet) text formatting commands, which allow you to easily specify:

- Typeface (but the user still has to have it installed)

- Size (in points or pixels)

- Color

- Alignment

- Case (even small caps)

- Leading (called "line-height")

- Indent

There's more, but these are the text formatting-related ones that work best cross-browser and cross-platform.

CSS allows the designer to group a set of these text formatting commands and name them as a style, and to apply that style to individual words, paragraphs or even tags (such as a list style, a header style, or a table cell style). Like style sheets in print-based page-layout programs, Web designers can change how the text in their Web site looks by a simple change of the underlying style definition, and all the text with that style sheet attached to it will immediately change its appearance to match the new definition.

Using CSS instead of HTML 3.2's "hard formatting" for text is currently the preferred method—not just by designers for its power and ease of use but by the W3C for its adaptability with current and future versions of HTML and XHTML. Applied correctly, CSS will degrade gracefully so that users on v3 or prior browsers will still be able to read the document—it just won't look as nice. (See the Appendix for further CSS information.)

can use special characters that appear invisible in the browser window (but take up space) or completely transparent GIFs to push the text over, taking the place of spacebar and carriage return runs. You can't use your own bullets, but you can use HTML to make hanging indents for you, bulleted or numbered.

If you have some text that absolutely has to look a certain way regardless of browser version or HTML capabilities, then you should turn it into a graphic. One example is text on top of a navigation button—the two elements have to be combined into a single graphic, because you can't overlap text on a graphic in a Web page. You should create the text and its button in your illustration program, keeping the text editable for easy changes down the line. When you go to the "convert to HTML" step, you would flatten a copy of the image, creating a single GIF for the button and its text.

Other text that frequently gets turned into graphics is logotypes, fancy section titles or subheads, unusual type treatments or incidental dingbats—single text characters you want to use as pictures.

Just keep in mind that text that's been turned into a graphic has some major disadvantages. First, the search engines can't index it, as they do live text, so it hurts your site's chances to appear in the top ten hits in a search engine. Second, it's a bear to edit or update. If it's live text, you can just type in new copy in the HTML file and upload the new page to the Web server; if it's a graphic, you have to open the original graphic (hoping you remembered to keep a layered, text-editable version), make sure you have the same typeface and color chosen, change the text, resave the file as a flattened graphic, open the Web page, delete the old reference and add the new one, then upload the new file and new graphic. And the third disadvantage is that a graphic takes far longer to download to the user's computer than live text, even if the graphic's file size is negligible.

Think Ahead: window size

You have a 17" monitor. Your client has a 17" monitor. Thus you create your prototype to fit the typical browser window on a 17" monitor. Right? Wrong, because:

1. There is no "typical browser window." Some users like to work with all the browser chrome turned on (the Favorites Bar, large icons and tags, etc.) which uses up some of the real estate within the window. At your site, users would have to tediously move and resize their window, and turn off some chrome, to see the entire home page, or they'd have to keep hitting those scroll bars. (Having to scroll vertically is acceptable, having to also scroll horizontally will aggravate people.)

2. It's unlikely that 100 percent of your site's users (the client's audience, remember them?) will have 17" or larger monitors. You must design for the audience! Even

if you're fairly certain that, say, 80 percent of the audience will have 17" monitors, is it acceptable to your client if the site is a pain to navigate for 20 percent of their clients and prospects?

The old standard of designing for a 640 × 480 (these are pixel measures) screen still applies in most situations today. This is the size that fits comfortably in a default browser window on a 13" to 15" monitor screen. Many designers go even smaller width-wise and try to stay within a 580 or 600 pixel width. The reason is because recent versions of Internet Explorer have vertical chrome that will eat into their "width" real estate.

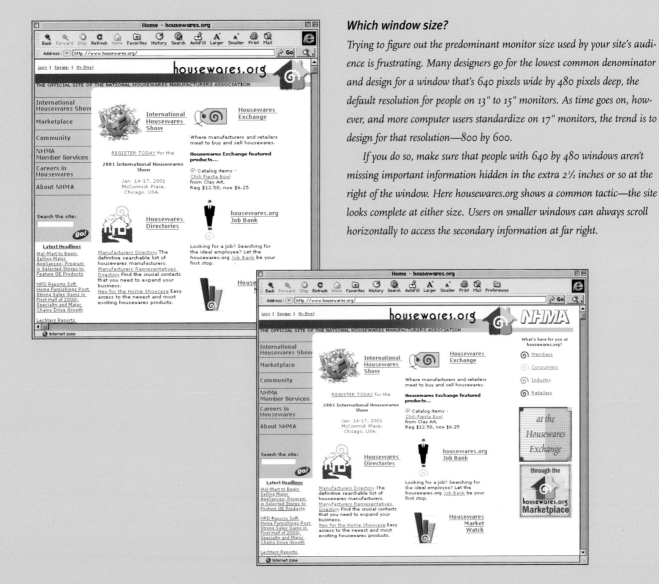

Which window size?

Trying to figure out the predominant monitor size used by your site's audience is frustrating. Many designers go for the lowest common denominator and design for a window that's 640 pixels wide by 480 pixels deep, the default resolution for people on 13" to 15" monitors. As time goes on, however, and more computer users standardize on 17" monitors, the trend is to design for that resolution—800 by 600.

If you do so, make sure that people with 640 by 480 windows aren't missing important information hidden in the extra 2½ inches or so at the right of the window. Here housewares.org shows a common tactic—the site looks complete at either size. Users on smaller windows can always scroll horizontally to access the secondary information at far right.

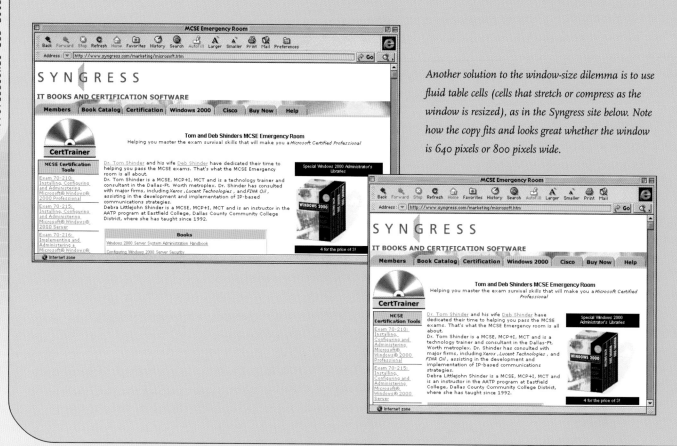

Another solution to the window-size dilemma is to use fluid table cells (cells that stretch or compress as the window is resized), as in the Syngress site below. Note how the copy fits and looks great whether the window is 640 pixels or 800 pixels wide.

By the way, the 480-pixel vertical measure is important only for the fact that it's what's first seen in a window, without the user having to scroll down. The most critical information must appear in the top 480 pixels: the logo, main navigation, compelling text and pictures, and so on. If the top 480 pixels' worth of your site looks good, users won't mind scrolling down to see what else you've got.

If you have some compelling need to design for a 17" monitor (roughly 800 × 600 pixels), at least try to arrange the content so that the right-most 200–250 pixels or so contain "secondary" information, like a strip of ads or a column of news blurbs. That way, after checking it out briefly, users on smaller monitors will know they don't have to scroll horizontally if they don't want to.

The other side of the coin is that on very large monitors (19" to 21"), 640 × 480 sites can look puny. Most designers try to compensate by either setting up "fluid" table columns or frames so the text wraps to the scroll bar, regardless of window width; or they employ tables or frames to always horizontally center the 640 pixels' worth of Web page within the window.

Think Ahead: color

One nice thing about color and the Web is that designers can specify the exact colors they want to use for text, links, graphics and Web page background colors. All colors are specified as RGB (red, green, blue) because that's how monitors create the

colors. Print designers can really let loose when doing Web design because the RGB spectrum is far larger than the CMYK (cyan, magenta, yellow, black) spectrum. (RGB is the native color space of all digital color images. CMYK is the four standard ink colors used in combination to create full-color images on a printing press.)

But (there's always a but) there are a couple of issues to keep in mind here. First, colors look different from monitor to monitor. Think of a bank of TV screens at your local Circuit City and how those screens look different even when they're all tuned to the same channel. The same thing is going to happen with your users. Aggravating the situation is the fact that colors appear noticeably darker and muddier on Windows than on Macs, even if they have the same RGB specifications. (Which means, Windows users, that colors look lighter and more washed out on Macs. Just trying to be fair here!) So whichever platform you're using to create the prototype design, keep the other platform in mind. As always, your audience comes first—if most of them will be connecting from Windows machines, and you're designing on a Mac, don't place dark-colored text on slightly darker backgrounds, because the text will likely be unreadable on a PC, when the whole thing darkens.

Second, there's the issue of browser-safe colors. (See art on next page.) These are the only 216 specific RGB colors that you can rely on being available to your site vis-itors regardless of computing platform, even if the user has an older, underpowered monitor set to 8-bit resolution, or 256 colors. If you use an RGB color outside of the magic 216, and a user on an 8-bit monitor visits the page, the system will attempt to "fake" the color by dithering—mixing pixels of two or more closely related colors that it does have available. Dithering looks like noise, or a faintly snowy screen.

Yuck. Of course you don't want that to happen. But how many users still have these types of monitors? That's an ongoing debate in Web design circles. I have heard speculation that even 24-bit (full color, 17.6 million of them) monitors are shipped with the default setting of 8-bit or, more often, 16-bit ("true color" on Windows, "thousands" on Macs) because manufacturers aren't sure if end users will have enough video RAM to run the monitor in 24-bit mode. (Thankfully, color shifting and dithering on 16-bit monitors is much less severe than what is seen on 8-bit ones.) Knowing that most users never change factory defaults (especially for something so esoteric as monitor resolution), sticking with the browser-safe 216 palette is still a legitimate practice.

The problem is that the palette is so limiting it's ridiculous. One solution (we've adopted this at our design studio) is to make sure that big swatches of color, such as page and table background colors, are from the 216 palette, but to feel free to spec any other RGB color for smaller elements like text color and incidental graphics.

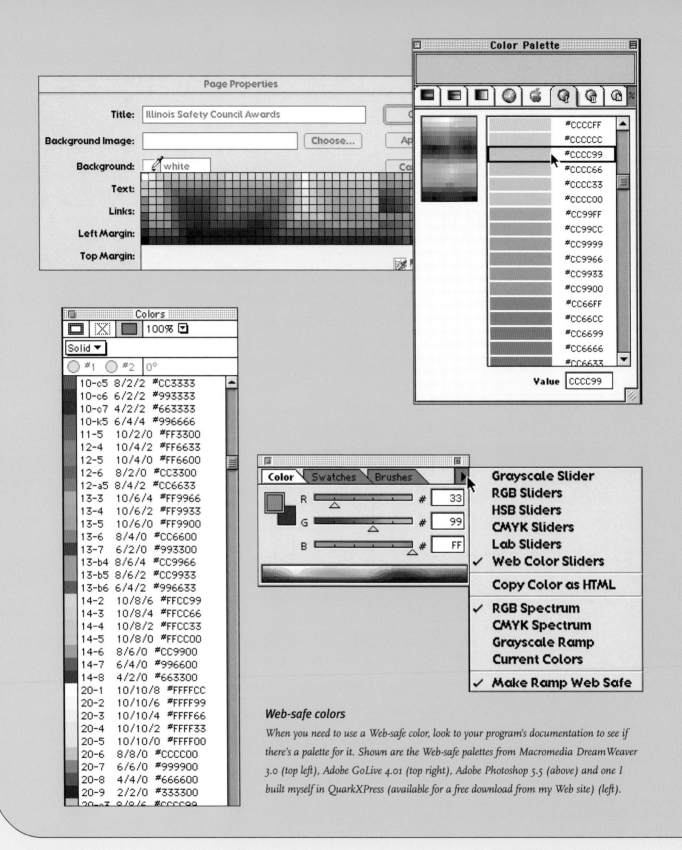

Web-safe colors

When you need to use a Web-safe color, look to your program's documentation to see if there's a palette for it. Shown are the Web-safe palettes from Macromedia DreamWeaver 3.0 (top left), Adobe GoLive 4.01 (top right), Adobe Photoshop 5.5 (above) and one I built myself in QuarkXPress (available for a free download from my Web site) (left).

In chapter four, you'll find more HTML tips and workarounds to help you out. But at this point, I've covered the major issues you'll need to keep in mind when designing your first set of Web page prototypes. You are now officially ready to start flinging pixels around. Get to work!

Site Design Presentation Process

Typically, clients (or bosses, or committees) will want to see at least two or three different design approaches for the first proofing round. As explained in the previous section ("Web Design Guidelines: Caution! Falling Pixels Ahead"), these are normally in the form of nonworking (non-HTML) prototype layouts created in Adobe Photoshop, CorelDraw or a page-layout program like QuarkXPress or Aldus PageMaker, converted to 72 ppi and presented on a monitor to closely mimic a Web page.

The actual number of designs, and to what extent you will carry them out (that is, how many sample Web pages you will create for each approach) should have been agreed upon already, and are assumably spelled out in your quote or estimate for the project. Just know that at some point during the design proofing process, you want your client to have the opportunity to see, comment and approve not only a sample home page, but also a representative page for all the other major types in this site: section openers, subsections, text-heavy pages (like newsletter articles or help files), forms, product thumbnails, picture galleries and the like.

How you'd like to carry out the design prototype proofing rounds is up to you, of course; this is more of a client- or project-management strategy than a Web design strategy. In the end you want to have them sign off on all the major elements of the Web design, allowing you to dive into production of the site (discussed in chapter four) without having to seek further design approvals or—horrors—having to redesign pages or entire sections after you've painstakingly converted them to live HTML pages.

Let me share with you how my company handles the design prototyping phase these days—a method we've developed over the years as we've been creating Web sites for clients.

When I first started out in Web design in 1995, I translated my studio's usual procedures for working with print clients to my new Web clients. For a print project's initial design presentation, we normally provided "three design approaches, each applied to a cover and inside spread." So in my quote to Web clients, I'd say that at the first design presentation, we would show them "three design approaches, each applied to a sample home page, and a set of representative interior pages—section page, sub-section page, text-heavy page and form page." (There are no "inside spreads" in a Web site!)

After my first few projects, though, I realized that for most of our clients (who didn't have huge Web site budgets), this amount of work for the first round was overkill. Creating and refining three different design approaches for a home page

and all its elements, plus all the interior pages, was a lot of work and cost the client a lot of money.

By closely observing their reactions during the initial design presentation, I learned that 90 percent of what they were focusing on was the home page. If they didn't like the look of one of the approaches, they barely glanced at its matching interior pages. And after all that work!

If you think about it, though, it makes sense. The home page is the "face" of the Web site. It communicates the design message ("We're a fun company!" or "Your money is safe with us"), shows the major divisions of the site structure (via its navigation buttons or labels), and gives some clue as to the site's audience and its primary goals.

Web prototyping in Photoshop

Any bitmap image editing program that has a layers feature is great for Web page proto-typing. Here I'm using the designer's friend, Adobe Photoshop 6.01.

When you create a new document, set its width and height at the pixel measures you've decided to use for your site. The resolution should be 72 dpi and the color mode RGB.

If you arrange Web page elements in layers, you can either show all the layers to see a composite of the page, or isolate layers to edit them without ruining other parts of the image.

When you're done with your page, save a copy of the composite in GIF or JPEG format and put that in a Web page for your client to review. This last screen capture shows the side-by-side image comparisons you can do with Macromedia Fireworks (the same feature is available with Adobe Photoshop 6.01).

That's a lot to take in at one time. Clients looking at home page ideas for their first Web site often gaze raptly at each one, lost in thought. It's like a blind person gaining the sense of sight and looking into a mirror for the first time. They're thinking, "So this is us, huh? This will be our face to the world, every minute of every day. Let me think about this."

So now we go with the flow. At the initial design meeting, we limit what we present to two or three fairly tight home page prototypes, using dummy text and photos. Even if the site's interior pages will have a substantially different layout than the home page, showing just the home page designs at this point will give the client a solid sense of how the entire site will look. After all, the inside pages will assumably carry out some of the same themes as the home page—color, page width, body

At the initial design meeting, we limit what we present to two or three fairly tight home page prototypes, using dummy text and photos.

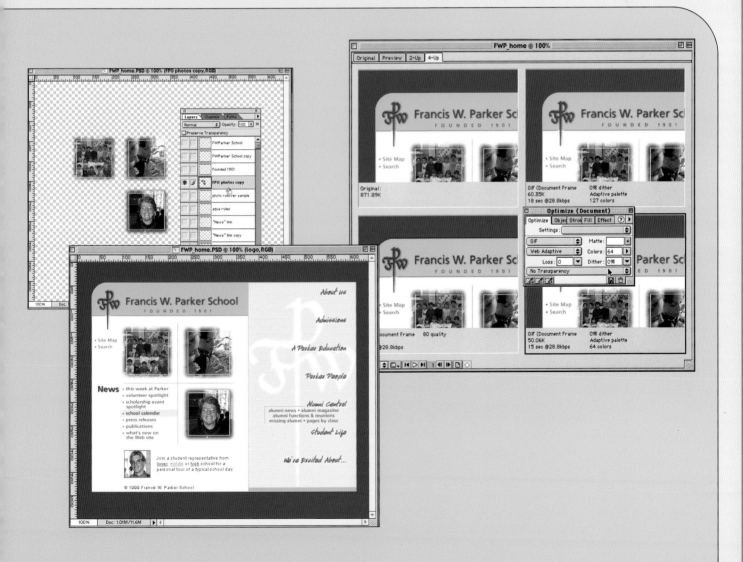

text treatment and so on. Of course we've thought about how each home page's look could be carried out throughout the site, and often describe to the client how it would work right off the bat.

For every successive design proofing round, we rework the chosen home page according to what we learned from our meeting, and incrementally add representative interior pages that would "go with it," refining those too as we progress. It seems to be the most efficient way for us to handle this phase, so you might want to consider it too.

Whichever method you choose, here's where you want to end up: The client approves all the representative prototype pages. Does that mean you're done with the design development phase? Almost!

Caution! Print Lies

Take it from someone who learned the hard way: Always make your Web presentations on a computer monitor!

You may be tempted to print out your designs to a color printer and mount them on presentation boards. If you're a print designer, you know this is the best way to make a professional presentation.

The problem is one of heightened expectations. Computer printers, from inkjets to laser printers, have a far higher resolution than a 72 dpi monitor. So when you print your Web page design from the illustration or page layout program you used, the type looks sharp (even at 7 point), colors get close to Pantone specs and photos have fine details.

But living, breathing Web sites are viewed by your client's audience on low-res computer monitors. At 72 dpi, 7-point type is usually an unrecognizable blob because there are only about 3 or 4 pixels available to create each character. Colors vary widely depending on age and condition of the user's monitor. Detail in contone photos is lost.

I assure you, your clients will not be happy when the design they approved on boards appears to be a far lower quality when viewed in its final form, on a computer monitor.

It's best to avoid the issue entirely. Present Web design proofs by making Web pages out of them and have the client view the designs with their Web browser. If your design is still in the prototype stage—not a Web page yet—just create TIFFs (Tagged Image File Formats) of each page; or take a screen shot of them at 100 percent scale, convert these images to GIFs or JPEGs and insert each page image into separate HTML files with your Web-authoring software.

Wrap Up With an HTML Sign-off. For the final design presentation, you need to recreate all the signed-off prototype pages as actual, live HTML pages and show them to the client for their approval. Nothing to it but to do it: You open your illustration program, open your Web-authoring program, and create GIFs and JPEGs, tables, text links, everything that's called for. By this time you may have some actual content (remember the Content List?) that you can use; if so, by all means include it.

Of course, if you're just doing the design, and handing off the pages to a programmer for HTML-izing, then this is the point where you do your first hand-off.

If you've done the proper amount of "thinking ahead," the conversion process should go fairly smoothly. The client might not even pick up on the fact that the Webified version of the design proof is different than the prototypes they've seen—until they click on a link and it works, that is.

You can conduct a monitor-based presentation in one of two ways:

1.

Live on the Web: Before the presentation, upload the pages to your Web server in a new directory. You may want to "password protect" the directory if the client is concerned about security. At the client's site, use your laptop or the client's computer to connect to the Web and call up the URL for the first home page design.

2.

From a local drive: Put the HTML files and images on your laptop, if you have one, or on a disk if you don't. At the client's, start up your Web browser and choose File/Open to open the first Web page design. If you don't have a laptop, copy the Web site files to the client's computer and open them up from their browser.

Once a client has seen and evaluated the design proofs on the monitor, there's little problem with giving them printouts for their files, or to take back to their office for mark-up. Just make sure you print out the files *from the Web browser screens,* not from your original illustration program.

Time for the presentation!

After you've created Web page prototypes and put each design into a separate Web pages as a large image, add an index page. The Deep Waters page shows links to the three home page prototypes created for this client. Now when you start your song and dance, this page can be on the screen while you introduce the designs, and it's also handy for clients to revisit after you've left (so they only have one URL to memorize or bookmark).

This is a very basic index page; I've seen some that have explanations of design methodology, thumbnails of alternate prototypes, animations, etc.

Design Presentation Process

The design presentation process

Start out with two, three or more home page designs and a working knowledge of how internal pages might look for each. The client will likely choose one of these and request some modifications.

The second presentation applies their modifications to the chosen design and carries out the design to a few internal pages. You might have to do this more than once.

The final design presentation would take the client's most recent design modification requests (which should be minor at this point) and apply them while you're creating a working HTML version of all the pages they've seen so far and perhaps a few more. It's important to show the client how the site will look as actual HTML since there's always some slight differences from the non-working prototype.

Once the client approves the HTML version, you're ready to go into production!

HTML

HTML HTML HTML

HTML HTML HTML HTML

DESIGN PROOF SIGN-OFF

More often, though, you discover some things that you thought would work in HTML actually don't, so you have to modify one or more elements. This is the downside to the "first prototype, then Webify" strategy; no one likes to have to change what the boss has already approved. (Considering the difficulty in creating working Web pages from the start, though, I still believe it's a risk worth taking.)

So, make the changes necessary to get the site to work, and show it to the client. By this time you and they will have developed a solid working relationship, and they will likely be remarkably understanding when you explain why you had to make the changes that you did.

Sometimes you get a sign-off on the HTML files right away; other times the client wants to tweak them, now that they see them as actual Web pages. In my quotes I usually include some time for this. But if they're asking for minor changes, I just ask them to sign off on the files "with changes" so we can get on with production.

```
function changeto1()  {
document.layers["text"].document.write("<fo
color=blue><a
  p://www.uphere.com>Lin

<head>

<script language="JavaScript1.2">
function changeto1(){
setTimeout(changeto1    "1")

function changeto() {
document.layers["text"].document.write("<font
color=blue><a
    ef=http://www.uphere.com>Link
```

```
<head>

<script language="JavaScript1.2">

function changeto1(){
setTimeout(changeto1,  "2");
}

function changeto1()  {
document.layers["text"].document.write("<font
color=blue><a
href=http://www.urlhere.com>Link
Here</a></font>");
document.layers["text".document.close();
}

function changefrom(){
            changefrom1,  "1");
```

putting it all together

Pre-Production

Your client has probably been sending you content—text files and images—in various formats for inclusion in their Web site ever since you and they came up with the Content List (chapter two), and it's likely that flow has not yet ebbed. Besides periodically goosing the client when they're running late getting content to you, your ongoing task here is threefold: Track the stuff that comes in, organize it on your hard drive and prepare it for Web site production.

Track content

When content comes in, it should be marked "received" and dated, both on the floppy disk (or other digital medium) and/or any hard copy they sent, such as print-outs, original publications or photo prints. Note this on the Content List as well.

Verify all digital media as soon as it comes in:
Mark it off as received in the Content List, open up any attachments to make sure they're usable and save them to your project folder.

Verify all digital media as soon as it comes in. Copy the files on the disk to the client's project folder on your hard drive and open them up. Sometimes the disk is damaged, sometimes clients think they put something on the disk that's actually missing, or is the wrong version, or it's in the wrong format, and sometimes a file or two is corrupt and can be copied but not actually opened. If any of this happens, jot down a note about it on the Content List and contact your client as soon as you can. Wait too long before calling and you run the risk that the person who gathered the files for you might have deleted them from her hard drive or left for her six-week cruise of the Caribbean. (Besides, it's never any fun having to call up a client and say, "Remember that Zip you sent me last month with all the scans? Well I just now realized I can't open any of them.")

If content arrives in the form of digital attachments to e-mails, or even in the body of an e-mail ("Here's the copy we want for the home page: . . . "), do the same thing: Mark it off as received in the Content List, open up any attachments to make sure they're usable and save them to your project folder. Save copies of e-mail with embedded content to the same location.

Organize content

Keep at least three content folders going on your hard drive for every Web site project, as follows:

Site Folder: actual, working HTML files, final GIFs and JPEGs, and nothing else. This is what you'll be uploading to the Web server when the site is complete.

Client Originals Folder: the digital files—unchanged—that you've received from your client. If they need to be worked on, save a copy of the file in the production folder, which I discuss in the following paragraph. That way if anything goes wrong,

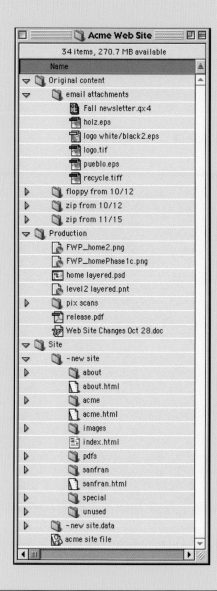

Control project files or they will control you
Always keep at least three folders going within a client's
Web site project folder: one to hold the raw content as it
comes to you (I put them in subfolders named according
to the date we receive them), one to hold production files
and one as the root directory for the actual site files.

you still have the original to start over with, even if you already returned the disk to the client.

Production Files Folder: all the content that doesn't belong in either one of the aforementioned folder categories. This includes your illustration program design prototypes; scans you've done for the site in-house; copies of any of the "client original" files you're currently working on to extract text or convert to ASCII; files you've received from freelancers; templates you've created in a Web graphics program (like ImageReady or Fireworks) to produce navigation buttons, rollovers and animations; and all other files "in transition."

If the site you're working on is very large or complex, you'll probably want to add subdirectories to the folders for client originals and production files. But in your site folder, don't add subdirectories or move files around unless you're positive this won't affect existing hyperlinks, which rely on permanent filenames and directory structures to work properly (more on this in "Putting Pages Together" on page 88).

Getting text ready for production

Text is ready for Web site production when it exists as a digital file in plain ASCII format, with or without formatting-related HTML tags. From this file you can copy and paste the text right into your Web-authoring program and format it—add tags for bold, italic, numbered lists, links—using the program's built-in features.

Since most e-mail comes through as ASCII, any copy the client's furnished within (not attached to) the body of an e-mail message is ready to go. To help keep things all in one place, you might want to copy and paste this text into a new word processing document (or just use Simple Text or Word Pad), and save it in your production folder with an appropriate filename, such as "home page copy.txt."

More often, text that the client wants to use for their Web site, especially if it's text that they're repurposing for the Web, is not available as an ASCII file and will need further processing.

If the text is provided within a computer document created in a particular program, you will need to have that program on your hard drive to open it. That's something that should have been hammered out when you were creating the Content List with the client. Even if the client is using a different word processor, illustration or database program than you, most major programs allow them to save a copy of the file in a more generic format that your programs can open. For example, spreadsheet and database programs can save information in "tab delimited" format, which is an ASCII document that contains the field data separated by tabs. All word processing programs and most any database or spreadsheet program can open these files.

Microsoft Word is an especially handy program to own. As long as it was installed with the "full feature set" option, it can automatically open documents, formatting intact, that were created in a huge variety of other programs. From there you can save the file as Text Only (ASCII), or choose Save as HTML, which creates an ASCII file with HTML tags that duplicate the original formatting. While you probably won't be able to use the HTML files as is, you can open the files right in your Web-authoring program and copy and paste the text and tags into your client's Web pages, saving you some production time. (Did you know that you can even use Word as a Web browser? It's very cool—check it out sometime!)

File

New...	⌘N
Open...	⌘O
Open Web Page...	
Close	⌘W
Save	⌘S
Save As...	
Save as HTML...	
Versions...	
Page Setup...	
Print Preview	
Print...	⌘P
Send To	▶
Properties...	
1 Mid school comm service	
2 bios.doc	
3 Mac HD2:Downloads:Classes to improve your Life.do	
4 Mac HD2:Downloads:Epermission Webmonkey.doc	
5 Site outline	
6 Content List 9/1/99	
7 Macintosh HD:Content List 9/1/99	
8 Macintosh HD:Desktop Folder:Site Goals	
9 Macintosh HD:Desktop Folder:Sites Goals	
Quit	

Converting text

If you can open up a file in Microsoft Word—which can open a plethora of different word processing and database files—you can save it as HTML and then open that file in your Web-authoring program. Though you'll likely have to clean it up and format it, at least it will save you some time in formatting simple elements like bold and italic and lists.

Macromedia DreamWeaver has a special "Clean up Word HTML" function that can automatically delete some Word-specific code that is seldom needed when using a different authoring program.

Text files that come embedded in a page layout program are a harder nut to crack. Extensis' BeyondPress 4.0 extension to QuarkXPress makes short work of exporting text and graphics from XPress files and turning them into HTML files.

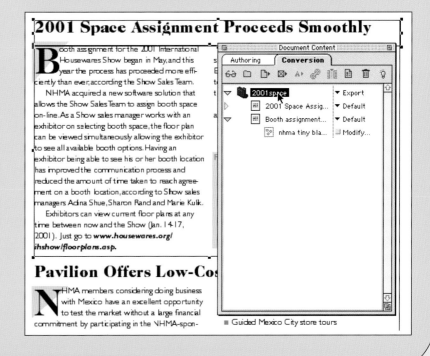

If you're going to do Web sites for a living, though, you should probably invest in some file translation software like MacLink Pro (for the Mac) or HiJack for Windows, for the inevitable weirdo file that comes in under the radar.

Text files provided as part of page-layout documents (QuarkXPress, Aldus PageMaker, Microsoft Publisher) are a little more troublesome. Since these programs can't save documents in formats other than their own (and translation programs can't touch them), you definitely will need to have the program installed, at the same or later version, if you want to open the file. If you don't have the right software, you can always pay someone or some company (service bureaus are a good bet) who does own the program to open the file and get the text out for you.

The good news is that all three of these programs have a Save Text option that automatically creates new ASCII or Microsoft Word files out of each individual story in the document. Many even have a Save As HTML or Export to HTML option.

Finally, text that only exists in printed format—no digital file to be found—needs to be typed into a word processing document and saved as ASCII. If there's a lot of text, you may want to consider scanning the pages and then running them through an Optical Character Recognition (OCR) program, which converts the scan to actual characters with varying degrees of accuracy. But in my experience, if there's so much text you're considering the OCR route, it can be cheaper and easier to simply job it out to a fast keyboarder.

Getting images ready for production

The goal here is to get all your images into digital format and save them as 72 ppi GIFs or JPEGs. Is that how you should ask your client to provide their images? No! Any greenhorn can save a text document as ASCII, but it takes a skilled professional to convert a standard scan to the crispest, clearest low-res GIF or JPEG possible. And once it's in that format, it's almost impossible to fix, since there are so few pixels to work with. So ask your clients to give you any bitmap digital files in high-resolution (at least 150 ppi) RGB, TIFF or EPS format. If they've got vector artwork created in Illustrator, Freehand, or CorelDraw, ask for a copy of that file saved as EPS (Encapsulated PostScript); you will rasterize (convert to bitmap) this artwork in your bitmap image editing program.

Often, clients don't have a scan to give you, and instead will send over photo prints (no problem, just scan and proceed with the Web conversion), slides (if you lack a slide scanner, send them out to a service bureau) or transparencies (ditto).

The big problem is when they give you their yellow page ad—"Here's our logo"—or other printed material like brochures and newsletters with images they want you

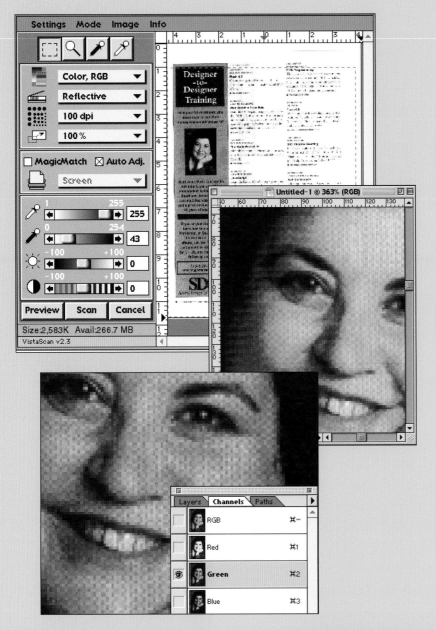

Oy vey, it's a moiré

Client gave you last year's annual report from which you're supposed to scan photos for the site? Lucky you.

When you scan printed photos, as I'm doing here to this display ad (who is that lovely woman?), your scanner picks up the halftone dots used to create the image. Often, the end result is the pronounced plaid patterning appearing here, known as a moiré pattern. Sometimes you can isolate a channel—the greyscale image you see is the green channel of the RGB scan—that has the most pronounced moiré, blur that a bit or run other filter tricks, and eliminate the worst of it.

The text explains some other methods of getting rid of moiré, but the very best way is to require original continuous tone prints or transparencies from your client.

Compare and contrast

It's tricky to get good-looking Web graphics, especially when they're photos of the client's products. The fact that they're only 72 dpi means that there's not much room for detail. On top of that, you have to compress the file for a quick download—either GIF or JPEG.

Adobe Photoshop (shown here) and Macromedia Fireworks have a feature that allows you to compare the effect of various color and compression settings on the same piece of Web art. These programs make it much easier to find just the right trade-off between file size and image quality.

to scan for the site. These are not continuous tone images like prints or slides. They're halftones, a necessary conversion that was created when the film was output for the printing plates. Halftone images are made up of only one to four colors of thousands of tiny dots of ink. Each dot is part of a straight line of similarly colored dots in an angle that crisscrosses other colored lines of dots, and there are anywhere from 80 to 150 lines of dots per inch for each of the one to four colors.

The different sizes of dots combined with how they're arranged all result in the pattern looking like an image when seen from "far away" (like five inches). But it's not an image; it's a dot pattern. When you scan preprinted images, you're scanning the angled lines of dots, not the image, and therein lies the rub.

Few desktop scanners can pick up all these tiny dots, but they give it a shot, and present you with a degraded facsimile of the image. The crisscrossing lines of dots often interfere with others, resulting in a pronounced plaid pattern look, known as a moiré pattern. Moiré patterns are notoriously difficult to eliminate without ruining the image.

By all means, try to get your clients to locate the original prints used to create the printed images. If not, perhaps their commercial printer or design firm who worked on the piece still has the digital scans archived somewhere. If neither of these pan out, then you'll just have to bite the bullet and do the best you can with the scan of the print piece. If your scanner has a Descreen command, you might want to try that first. (Descreening is the process of converting halftones back to continuous tones; the lines of dots are known as a line screen.) If you're lucky, that'll do the trick. But unfortunately, most often you'll end up with a blurry plaid thing.

It's time to try some custom manipulations instead. I've found that scanning at a very high resolution (400 to 800 ppi) and scaling the image down in size before you do anything else often helps get rid of moiré, as does placing the page on the scanner at an angle (try 15° and 30°) and then rotating the image back to true in your image editing program. Downsample the image to 150 to 300 ppi before you proceed with further manipulations.

When you're working with scans or rasterized vector images, do all of your color balancing, sharpening and resizing while the image is still in its high-res, 150+ ppi mode. You'll get better results because the program has more pixels, and a greater color range, to work with. If you're accustomed to using the Unsharp Mask feature to sharpen scans for print, you should know that Web graphics often look better with settings that are a bit more drastic. Experiment!

Now you're ready to downsample the image to 72 ppi and save it as a GIF or JPEG. Remember that GIFs are best for flat colors (like logos you've rasterized from

vector EPSs), and JPEGs are better for photographs and illustrations with a lot of color gradations. Also, only the GIF format supports transparency.

Most any bitmap image editor can save a file in either of these two formats. If you have many images to process or you want the absolutely best results, it pays to use a program or plug-in that specializes in Web graphics. Not only are they better at squeezing bytes out of a file without squeezing quality, but ones like ImageReady (integrated with Photoshop) and FireWorks let you compare side-by-side previews of the same file with up to four different compression settings applied to it, allowing you to choose the best compromise between filesize and image quality.

Proper file naming conventions

When you save your final JPEGs or GIFs to your site folder, name them correctly.

First, make sure they have the proper extension—the three or four characters following the "dot" that indicate what sort of file it is. GIFs get the ".gif" extension, JPEGs can have either the ".jpeg" or ".jpg" extension. If the extension is missing, the Web server will not understand what sort of file it is. The default setting for Windows always adds the correct dot extension to filenames but hides it from you in the filename field, so be careful of adding them on your own (or you'll end up with "logo.gif.gif"). You can change Windows settings so automatic filename extensions are always visible.

Most Web servers run on the UNIX/Apache operating system, which means that filenames are also case-sensitive. An HTML page that has an tag calling for "Logo.gif" to appear will instead get a missing image icon if the file is actually called "logo.gif". The easiest way to eliminate this worry is to keep all filenames, including images, either completely lower case or upper case. Decide on one method and stick with it throughout, including for HTML and subdirectory or subfolder filenames.

Filenames for the Web can consist of the basic twenty-six alpha characters, the ten digits (0–9), the hyphen, and the underscore. The period is only allowed when it precedes the extension. Although you can use other characters in filenames, when the URL containing the filename appears in a browser's "Location" field, it gets translated to a UNIX equivalent. The most widely-seen example of this are Web site files with spaces in them, which get converted by the server to "%20". So www.acme.com/1999 portfolio/award winners.html looks like www.acme.com/1999%20portfolio/award%20winners.html. It screams "amateur!" so don't do it. Use hyphens or underscores to separate filename words instead.

Remember these filename rules when you're creating and naming your HTML files and folders, which I discuss in the next chapter.

Remember that GIFs are best for flat colors, and JPEGs are better for photographs and illustrations with a lot of color gradations.

Consider Creating a Project Site

Large complex sites, a lot of content flying back and forth, many sign-off milestones, faxes, e-mails, proofing rounds, vendors working on specific sections in various stages of completion. . .How can you keep it all together?

Try a project site. It's a bit of work to set up initially, but not only will it keep you and everyone else on track, it reassures clients that you are handling all the details with care (and impresses the heck out of them too).

A project site is a Web site that you create for tracking and managing a Web site under construction. It can be as simple as one page with your logo, the name of the project, contact information for everyone involved in the project, links to the current version of the site and a series of progress reports posted in single dated paragraphs.

You can expend a bit more effort and make a little jewel of a project site complete with rollovers and pop-up menus, and links to pages you've added with other useful information:

- Latest version of the site in progress

- Archives of previous site versions

- Individual HTML pages in need of client proofing

- Content List with upcoming deadlines highlighted

- Production schedule

- Biographies and photos of team members

- A group calendar for scheduling meetings

- A bulletin board for public discussions amongst the Web site team

- Design and production specifications/reference for subcontractors

- A form for uploading digital content to your FTP server

- Password-protected areas for tracking billable hours and payment status

Once you create your first project site, it's a simple matter to duplicate it and adapt it for use with other Web site clients in the future. Keep in mind that most clients are uncomfortable with putting up pre-release information on the Web at large, so you should assign a general password to the project site as a whole that is only given out to team members. This can easily be done with your Web host.

A project site makes it easy for everyone involved with a Web project to keep on top of things. Exotype sets up password-protected directories for its clients, accessed through a little corner of the design firm's home page. Once logged in, clients, vendors and members of the design team can view tasks, proofs, timelines, contact information and all the other errata that make up a site development project.

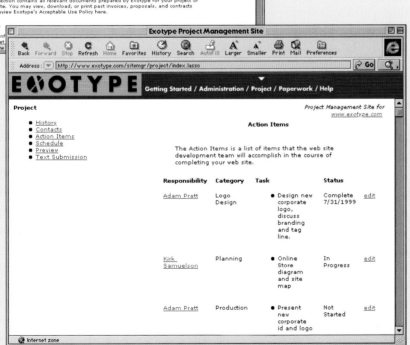

Putting Pages Together

Use a Web-authoring program

To actually assemble the Web pages, and link the pages together into a Web site, you need a Web-authoring program. Wait—I take that back. You don't need a special program; you can put together a Web site using any word processor and a field guide to HTML tags if you want. These are known as hand-coded sites. If you're the sort that prefers to cook your dinner by rubbing two sticks together to make a fire, boot up your text editor and go at it!

But unless you were on the Web train from the beginning, the learning curve facing late arrivals is nosebleed high. Web sites are far more complicated today than in 1995 because the bar has been raised to lofty heights. Not only must you be familiar with HTML in all its versions, but you'll likely also need to know JavaScript, DHTML and CSS, plus how to get them all to work correctly together, cross-platform and cross-browser.

Also, in your spare time you might want to study up on QuickTime, RealAudio, Flash and SQL.

A professional Web-authoring program can magically turn you into an accomplished Web designer even if you have only a surface familiarity with many of these concerns. It lets you take a visual approach to design: You work on a Web page as though it were a page-layout document, placing graphics and text boxes, selecting text and choosing bold or bullet, setting up and applying style sheets, choosing Image 1 and Image 2 from a dialog box for your rollover buttons, drawing tables and dragging cell borders, etc. While you work, the program translates what you're doing to HTML, JavaScript and whatever else that's required.

When you're finished and you save the file, you end up with an HTML document that you can upload to your Web server, just as though you hand-coded it. Only other Web designers might know the difference (and only if they View Source for the document—some programs embed telltale tags attesting to their origins).

Now, it's not all trouble-free, of course. Software programs provide the tools, but you still must know how to use them. (If I gave you a box of carpentry tools, could you build me a house?) Web-authoring programs in particular require a working knowledge of HTML so users can exploit all their capabilities, to know what's possible and why a layout isn't working—and sometimes it's just more simple to do a task right in the HTML code (run a Search and Replace to change font specs, for example) than via the layout interface.

Thus, you want a Web-authoring package that not only provides a visual editing environment, but also:

1. gives you easy and complete access to the underlying code,

2. lets you edit the code,

3. immediately reflects what you did to the code in the visual preview to the page.

Making it relatively easy to create a Web page that works is one thing. The best Web-authoring programs also help you create and manage a Web site. They keep track of all the links between pages, and automatically update them when you change a linked file's name or move it from one subfolder to another. They let you do Search and Replace routines on all the site files at one time. Some can even synchronize all of a Web site's files between what's on your hard drive and what's on the Web server, making short work of updating and maintaining live sites.

Programs that do everything I've mentioned, and more, include Macromedia DreamWeaver, Adobe GoLive, Microsoft FrontPage, Allaire HomeSite, and NetObjects Fusion. DreamWeaver and GoLive are the most popular among profes-

The best Web-authoring programs also help you create and manage a Web site.

Best of both worlds

Using a professional Web-authoring tool like Adobe GoLive (shown here) or Macromedia DreamWeaver can really speed up your production. Both programs allow you to do things graphically or "the old-fashioned way" by typing in HTML code. Here I'm linking the Web page text "Take a history tour" to the file called "historytour.html" by dragging GoLive's point-and-shoot tool from the link dialog to the HTML file. With the linked text selected I switched to the underlying HTML view. Note how the same text is highlighted and surrounded by the link code.

sional Web designers, with DreamWeaver currently in the lead, probably because (1) they're the most visually-oriented, (2) the companies are well-established in the design and publishing industries, and (3) each is available for both Mac and Windows. It's still very much a horse race, though, and worthy new contenders still have a legitimate shot at capturing decent market share.

All the programs I've discussed so far output HTML files in the end, and all can open HTML files created elsewhere, so you're not really locked into any one program as you would be if you were choosing a page-layout program. If you're taking over a site created in DreamWeaver but you use GoLive, you can import the site files and "turn it into" a GoLive site, and vice-versa. Some designers use multiple authoring programs. While they create most of their pages in one program, they create certain sections in another program because it has better features for the task.

I'm not going to advocate any single Web-authoring program (though you should know our studio mostly uses GoLive). You need to try them out for yourself and see which one suits your working style best. Many of the packages, including DreamWeaver and GoLive, offer free, fully enabled thirty-day demos of their programs that you can download off their company's Web sites.

For the remainder of this chapter, I'll assume you're using a Web-authoring program to pull together the basic elements of your Web pages. Your program's manual will teach you how to place text and graphics, format them and link them to other pages, but keep in mind that the instructions are different for each program.

What I will provide here is information on everything else that goes into producing most Web sites nowadays, along with advice and techniques on how to easily and efficiently integrate these elements with your site, regardless of which program you're using. Some Web-authoring programs include these features, and I'll mention those as I go.

Some designers use multiple authoring programs. While they create most of their pages in one program, they create certain sections in another program because that program has better features for the task.

Organize your site files

When you're creating a Web site, the locations of the HTML files, images and folders make a huge difference in how quickly you can construct the site and how seamlessly you can transfer the files to a Web server when you're finished.

I mentioned earlier that you should maintain one folder to contain the final site files (working HTML files and final GIFs and JPEGs), and that's still true. While your Web-authoring program may allow you to place images on Web pages from folders outside your site folder or even from a network fileserver, that makes it very difficult to mirror your site on the Web server down the line, because you also have to mirror folder names and locations. If you drag items into a single folder *after* placing them in a Web page, it breaks the links, which depend on the file being in

its original location. So move that file into the site folder *before* you place an image, embed a sound or bring any other element into an HTML document. And of course, save all your HTML files in the site folder as well.

As far as how to organize files within the site folder itself, that's completely up to you. If you use your Web-authoring program's site management features (assuming it has them), you should be able to add subfolders, rename files and move files around from within the program, and it will update any links for you automatically.

Probably the most common way to organize files within a site folder is by mirroring the structure of the site itself. The home page always goes at the top level. If there's a button on the home page leading to, say, the "Publications" section, you create a subfolder called "Publications" and put all those files in there. Images and other assets (movies, sounds, flash files) usually go into one "Media" or "Assets" subfolder at the same level as the home page, since these are often used in multiple places throughout the site.

When you start drowning in media files, it can help the workflow if you add additional subfolders to the main media folder for specific types ("Flash," "Movies," "Sound," etc.). Another trick is to create a subfolder(s) to hold a set of image files related to a particular element, like the before-and-after images of your navigation bar rollovers, or the images from a sliced-up table. Doing that makes it much easier to locate and modify a particular file, since these often have cryptic filenames that were auto-generated from a Web graphics program.

There's no requirement to organize your files in folders and subfolders. You could put up a completely "flat" site if you want, with all files floating on the same level. But if you get beyond five or six HTML pages and ten or twenty images, it gets difficult to find files in dialog boxes and windows.

When you're naming folders and files, and organizing locations, keep in mind how the URL of important HTML files will read in the browser's URL field, or how it will read when spoken over the phone or sent to a customer in an e-mail. These exactly reflect the site folder's organization. For example, if you're doing a site for an animal shelter, and deep within one of the sections appears pages for adoptable pets, you might at first put these files deep within subfolders that help you organize them: toplevel/services/public/adoptions/mixed_breed-dogs/feral/fido.html. "Toplevel" means the root level of your site folder, where the home page is; visitors would see the domain name instead: www.shelter.com/services/ etc.

Can this URL be saved? It may make sense to you—after all, it reflects the site structure—and while there isn't actually a "Feral" button, you added it as a subfolder because there are so many individual dog pages and that's how the list was supplied to you by the client.

When you're naming folders and files, and organizing locations, keep in mind how the URL of important HTML files will read in the browser's URL field, or how it will read when spoken over the phone or sent to a customer in an e-mail.

But think of little Sally Jones who drills down into your cute site, arrives at the page of thumbnail pictures of Mixed Breed Dogs, and clicks on Fido's cute face to see his page. Sally bookmarks Fido's page because she wants to show her Mommy when she comes home from work. Sally isn't paying attention to the URL, but when Mommy sees from the Web page URL (which appears in the browser's Location field) that "Fido" is in the "feral" folder, she may be somewhat chagrined (!).

Or think of how often the staff has to direct callers to a particular URL. Owners of lost pets may frequently call, and the staff would like to tell them to check out a particular page to see if the pictured pet is theirs. How easily will the front desk staff

Smart site directories

If you're like me and keep all the image files for a Web site in one "images" folder, make it easy on yourself and organize those images into subfolders. Users seldom see these directory names so you have some freedom in naming them according to what's easiest for you. For example, I put the most frequently accessed files into folders preceded by a number so they're always at the top of the window when I'm viewing files in my hard drive.

On the other hand, you do need to take care in naming HTML files and their directories, since site visitors see them in URLs all the time. On the Lobster Gram Web site we put all the product pages in their own folder called "goodies." Thus when a visitor goes to a specific product page like "mainelobtail.html", it appears in their location field like this:

http://www.livelob.com/goodies/mainelobtail.com

There is no section or link on the site called "Goodies," but the company attitude and pride in their product is subtly evident whenever an interested visitor views those pages.

remember that URL, and how often will the caller swap the underscore and the hyphen (entering /mixed-breed_dogs/) by mistake?

In the interest of how people actually use the site, consider reorganizing parts of the site folder so that important or frequently used URLs are more user-friendly. In this example, you might want to maintain the structure leading to the thumbnail page as before:

www.shelter.com/services/public/adoptions/mixedbreeddogs/pix.html

... But when someone clicks a linked thumbnail picture on pix.html, they would arrive at :

www.shelter.com/petpages/fido.html

Isn't that better? Even though there' s no actual button on the home page called "Pet Pages" (in this example), it's a professional touch to create a section-level folder called Pet Pages just for the purpose of making a short and friendly URL appear. It's easier for clients to bookmark and easier for staff to remember. While it usually makes sense to mirror a site's flowchart when developing a file/folder hierarchy, it's not a requirement—sometimes it makes more sense to break the rules for a higher purpose.

Use templates

There is a lot of duplication that occurs in a Web site. Navigation bars often appear in the same location, headers and footers remain the same, "invisible" (borderless) tables designed to force columnar layout are the same size throughout a section. To cut down on your production time you should create template pages so you don't have to keep reconstructing the same elements from scratch on every page.

A page template is a Web page that has repeating elements already in place, with placeholder ("dummy") text and graphics standing in for elements that will have the same position or formatting but whose content changes from page to page. You're not actually going to publish (upload to the Web server) this page, you'll just use it as a starting point. Depending on your site design, you'll probably save the most time by creating multiple templates, one for each main "type" of page that occurs often throughout the site (section openers, product features, FAQs, etc.).

After you create a template page, all you need to do is choose Save As from the program's File menu, giving the new copy a real name, such as "shipping_info.html". In this document you'll replace the dummy text with the actual text, placeholder graphics with the correct ones and do any other sort of customization needed.

When you're ready to work on another page, save the current file and close it. Then open the template page again, immediately do a Save As with the next file-name on your to-do list and work on this new page. Don't forget the Save As step; otherwise, you'll be customizing your template instead of a new page for the site.

Macromedia DreamWeaver has a true "Master Pages" type function, similar to how master pages are used in page-layout programs, except they're called Templates. You can create an unlimited number of templates for a given site and specify which elements are modifiable and which are locked. When you modify a template that's been used to create pages in your site, you can have DreamWeaver update all those pages automatically.

Your Web-authoring program probably has a template or template-like feature built in. Look in the manual for anything that sounds like it means "template": Stationery, Master Page, Component, Libraries. DreamWeaver calls them—are you ready for this?—Templates.

Some programs have a related feature that not only lets you easily reuse existing elements or entire page structures, but automatically updates all repeated elements/pages when you update the "source" instance. Check the manual before you begin—it's no fun finding out that you could have saved hours or days of tedious work had you but known of this one automation feature before you started.

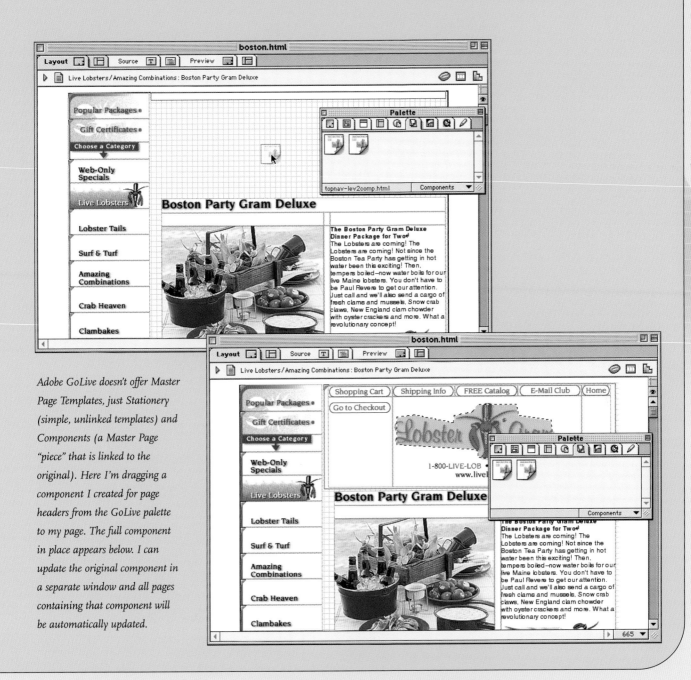

Adobe GoLive doesn't offer Master Page Templates, just Stationery (simple, unlinked templates) and Components (a Master Page "piece" that is linked to the original). Here I'm dragging a component I created for page headers from the GoLive palette to my page. The full component in place appears below. I can update the original component in a separate window and all pages containing that component will be automatically updated.

Add JavaScript

Want rollover buttons (the button graphic changes when your mouse "rolls over" it) in your pages? Those are accomplished with JavaScript. Want to have a pop-up window? You'll need some JavaScript code. Preload images so they'll appear faster? Redirect users to a different page based on the browser version they're using? Do you love those slick drop-down navigation menus? JavaScript, JavaScript, JavaScript.

JavaScript is an "almost plain English" programming language that lets you do things to Web pages that HTML can't do. Like HTML, it's applied by certain commands written in ASCII text. The JavaScript commands are combined with the HTML code, usually in the Header section (where the Title tag appears), but also within the body section. Older browsers (pre-v3, basically) which don't speak

JavaScript will produce error alerts or freeze when the page they're trying to show contains JavaScript, so people usually surround the JavaScript code with special tags that make it invisible ("hide" the Javascript) to them, and they're ignored.

Note that JavaScript is in no way related to the programming language known as Java, or to Java "applets" (which are a form of Java)! Weird, I know. JavaScript was actually developed by Netscape (the Navigator people) and was originally known as LiveScript. They changed the name to JavaScript back when Internet Explorer was first making inroads to the Web scene. Don't ask me why. I'm just glad the Internet Explorer browser, especially now that it's taken the market share crown from Navigator, has little trouble understanding JavaScript commands.

How can you add JavaScripted features to your Web pages? Let me count the ways:

First, you could teach yourself how to write JavaScript; there are a lot of books and online tutorials devoted to the subject. Learning how to "roll your own" JavaScript will allow you to develop all sorts of cool features for the Web sites you create, and to troubleshoot the scripts that aren't working. Just type them right in the HTML viewer in your authoring program.

Second, you could copy and paste other people's JavaScripts to your HTML documents. Remember, the Web is open source—take a peek via View Source to see the JavaScript someone is using on their page. However, you should always ask permission from the site developer to use someone's JavaScript, as these are sometimes licensed as Shareware (and sometimes require that you include a credit line or two within a comment code on your page). Unless you know something about how JavaScript works, though, you might find that someone else's code is not easily transferable to what you want to do.

Third, check out one of the many Web sites that list free and Shareware JavaScripts (see the Appendix). Some even have a search engine so you can quickly locate all of the site's JavaScripts that help you set up online quizzes, for example. Most come with instructions for adapting them for your own pages.

Fourth, major Web-authoring programs such as the ones I've mentioned come with pre-built JavaScripts that you can optionally include in your pages. Not every JavaScript known to man, of course, but at least the top twenty or so most frequently used ones, such as rollovers, form validators, and browser redirects. In GoLive, this feature is called "Actions"; in DreamWeaver, "Behaviors." GoLive also has an integrated JavaScript editor/validator that makes it easier to modify code snippets you've found elsewhere—even accomplished JScripters find this a useful feature for banging out custom code.

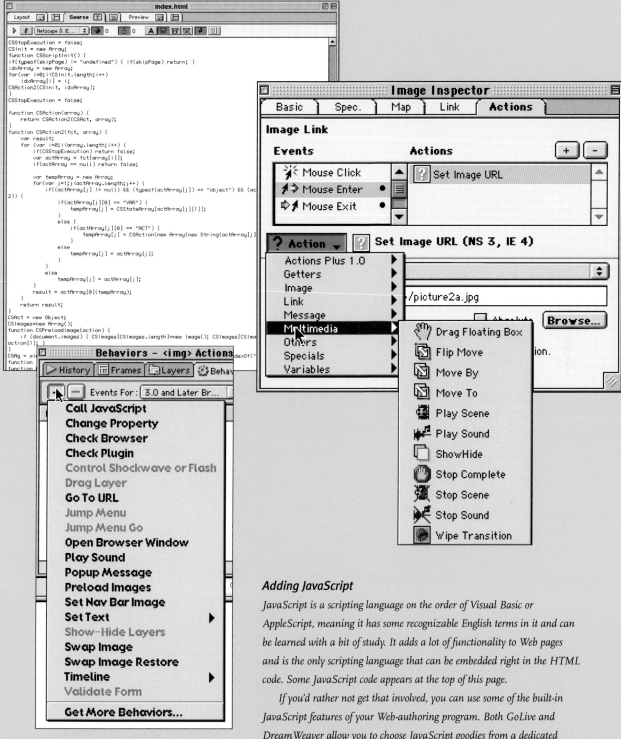

Adding JavaScript

JavaScript is a scripting language on the order of Visual Basic or AppleScript, meaning it has some recognizable English terms in it and can be learned with a bit of study. It adds a lot of functionality to Web pages and is the only scripting language that can be embedded right in the HTML code. Some JavaScript code appears at the top of this page.

If you'd rather not get that involved, you can use some of the built-in JavaScript features of your Web-authoring program. Both GoLive and DreamWeaver allow you to choose JavaScript goodies from a dedicated palette; GoLive calls these Actions; DreamWeaver, Behaviors. (Actually Actions and Behaviors are combinations of JavaScript, DHTML and CSS, but you don't need to know that.)

You're not limited to the ones that Adobe and Macromedia include with the program. There are many third-party sites that offer Freeware and Shareware Actions and Behavior add-ons, and/or you can go to the JavaScript sites and just copy and paste code into the HTML view of your site pages (being sure credit to the original author in a Comment tag).

Finally, if it's just rollovers you're after, Web graphic programs like Macromedia FireWorks and Adobe ImageReady not only let you create the images used in the rollovers, but can also write the HTML and JavaScript code required for them to work. Each program can output "generic" HTML files or ones targeted toward GoLive and/or DreamWeaver so you can modify them in that authoring program's own JavaScript interface. (I wonder how long this egalitarianism will last.)

Add forms

Web-authoring programs help you create Web page forms by providing icons that represent parts of a form—scrolling text fields, radio buttons, checkboxes and other similar features.

Web-authoring programs also help you create Web page forms ("Add me to your mailing list!") by providing icons that represent parts of a form—scrolling text fields, radio buttons, checkboxes, and other similar features. You just drag these elements onto the page and customize them as necessary. The program creates the underlying code. When a user fills out the form (enters data into the form fields you created) and clicks the Submit button, their data gets e-mailed to whoever you specified when constructing the form.

<RANT> It cracks me up whenever I hear of a company calling their Web site "interactive" just because they have a form or two. What's so interactive about a Submit button? </RANT>

Anyway, adding a form to your site has a few implications you should be aware of. First, Internet Explorer and Netscape Navigator present the same field in different sizes, even if you specified a set size for the field. The result is a form that's misaligned, sometimes to the point of nonsense, with field names not matching the fields they're next to.

To compensate for this you should always set up form fields in a table. Keep your live text field labels like "City:" in one column, and put the actual form fields in the same row but a different column. Make sure the column width for the form fields is wide enough to accommodate the size difference between the two browsers.

Another special consideration is that you, as the Web author, have to designate what happens when the user clicks the Submit button. At the very least you have to set the e-mail address that the form gets mailed to (your Web-authoring program will have a field for this information). The basic "mailto" form is problematic, though, because all the form data the user filled in and the field names that you set up get sent as one long run-in paragraph. It's hard to read for the recipient and almost impossible to process further on the "back end," such as when your client wants the form data to automatically get added to their local database.

Thus most Web designers will instead point the Submit button at a CGI program called "fmail.pl" on their Web server (fmail = form mail; pl = Perl). Perl is a scripting

language (in the same vein as JavaScript) used to create CGI programs that run on Web servers. I discuss CGI programs in more detail in the section starting page 102, Adding Goodies. For now, you only need to know that most Web host providers supply the fmail.pl CGI script pre-installed for all their clients because almost everyone uses it with their forms.

The fmail.pl script is popular because it does two cool things: (1) it breaks up the information in the e-mail that gets sent so that each field name and the data the user entered for that field is on a separate line; and (2) it lets you specify a "thank-you" page URL, a page that should appear after the user clicks the Submit button. ("Thank you for filling out our form! The information you entered has been sent successfully. Return to the home page?").

Your Web host will provide instructions on modifying the Perl script for your site, and your Web-authoring program will tell you how to set up your form so the data gets processed by it. Actually, there are a number of different Perl scripts and JavaScript scripts that can do things with forms; the fmail.pl is just the most common. Check out the Appendix for more sites that offer free Perl scripts.

Build Search Engine-Friendly Pages

If your client doesn't call you within three months after the site goes live to complain, "Our site isn't coming up in the Yahoo search engine," you better call them because they might be dead.

Truly, clients are crazy for search engines. Search engines are any one of a number of Internet sites that maintain an ongoing index of the text content of the pages in the World Wide Web and allow users to search for matching URLS—that is, Web pages that contain the text they entered for their search term.

But clients are going to get their hearts broken; search engines are woefully behind in adding all the current URLs to their databases, let alone new ones. (See the sidebar "Search Engine Myth-Busting" for the gory details.) Yet all is not lost.

Your site gets added to a search engine's database only after its indexing program visits your Web pages and indexes the text. These programs, also known as "spiders" or "robots" ('bots for short) run automatically; you don't need to submit your URL to them, they'll get to you eventually. However, if you do hand-submit your site (just go to the search engine and look in the footer for a "Submit" link), it might get you in there sooner.

You can tell when you've been visited by a search engine indexer by looking at your Web server logs (I discuss these in chapter five). Each one has its own cute name: lycosspider, inktomibot, and so on.

There are documented ways you can improve your site's ranking in the search engines once you get indexed. Some have to do with what's in the page (which I discuss here), other ways have to do with site promotion (discussed in chapter five). Not all search engines work the same way, so some techniques that are critical to one search site may be completely ignored by another.

Nonetheless, some of these methods have to do with what's in the Web page itself, and here they are.

Title tags

You may be surprised to learn (I know I was) that for the majority of the big search engines, the text in your Title tag—the text that appears as the window title when someone's looking at a Web page—is one of the most important indicators if your site is a good match for the search term. So give your Web pages titles that really describe what the page contains, and the more detail, the better.

"Untitled Document"—bad (you wouldn't believe how often people
 forget to add a Title)
"Shipping Info"—okay
"Acme Widgets Product Shipping Info"—better
"Acme Widgets Shipping Info for the Finest Steel, Bronze
 and Diamond Widgets"—best

Indexers like repetition. They love repetition. Repetition is what they love and like. Are you picking up on my subtle clue here? The more times your keywords—the search terms for which you'd like your site to appear in a "matches" list—are repeated within your page, the more likely your page will wind up higher in the matches list. So in your title text, try to repeat keywords from the body copy.

Body copy

I know that unless you're working on a site for yourself or your own firm, you probably don't have a lot of control over what a page's body copy says. However, you may be interested to know that the closer body copy appears toward the top of the page—especially copy that contains those sweet, sweet, keywords—the higher you'll rank with some of the search sites. Text links are also good; not only do they get indexed but the indexing 'bots follow those links to pages further in your site.

Also, the first 100 to 200 ASCII characters in the body section of your HTML page is what might be used for the "description" blurb of your site if it does appear in a search hit list. The description acts like a mini-ad for your site, so if you can make the first couple lines into something memorable, all the better.

ALT tags

An ALT (for Alternate) tag is an optional HTML tag you can add to every GIF or JPEG image in a Web page to describe the image. If you add an ALT tag to an image, visitors will see it briefly while they're waiting for the image to download. If you don't, they just see the default "Image" text placeholder. Web designers mainly add descriptive ALT tags to all their images so that sight-impaired visitors using Web page readers can understand what's supposed to be there. It's also handy for people using text-only browsers or who have turned off the "auto download images" feature of their regular browser to speed things up.

The key point here is that search engine indexers also index all the ALT tags, so they're a good place to stash more keywords. And did you know there's no limit on how long an ALT tag can be?

META tags

The "invisible to the user" header section of a Web page, in which the Title tag and JavaScript are entered, can also optionally contain various META tags for indicating site details such as authorship, languages used and contact information. Two of these META tags are of interest to designers optimizing pages for the search engines: 1) The META Keywords tag, which consists of keywords about your site that search engines use to categorize the site, and 2) the META Description tag, which is a sentence description of your site that search engines can read.

The Keywords tag lets you enter in a series of words or phrases, separated by commas, that you'd like the search engine to add to its index. These words don't have to appear within the page, indeed they could have nothing to do with your page at all. What's important here is that you input the search words and phrases for which you'd like this URL to appear in a list of matches. Not sure what those might be? Look at the source code for sites similar to yours and see what they're using (if they added the META Keywords tag, that is), or try running a search yourself and look at the Keywords tags for the top ten matches.

The Description tag is used by some search engines to add a brief description of your Web site underneath your URL link. It takes the place of using the first 100 to 200 characters of your body section.

Doorway pages

Consider creating one or more doorway pages at the same level as your home page. (It's more work, but if your client is really hot to get into the search engines, it should be worth it.) A doorway page is like an alternative home page, but completely

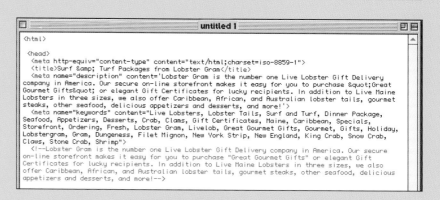

7. Surf & Turf Packages from Lobster Gram
Lobster Gram is the number one Live Lobster Gift **Delivery** company in America. Our secure on-line storefront makes it easy for you to purchase "Great ...
URL: www.livelob.com/surf-sec.html
Translate More pages from this site ⊡ Related pages Facts about: Lobster Gram

The Lobster Gram site turns up in the top ten hits of a search on AltaVista partly because of its META tags.

```
untitled 1

<html>

<head>
  <meta http-equiv="content-type" content="text/html;charset=iso-8859-1">
  <title>Surf & Turf Packages from Lobster Gram</title>
  <meta name="description" content='Lobster Gram is the number one Live Lobster Gift Delivery
company in America. Our secure on-line storefront makes it easy for you to purchase "Great
Gourmet Gifts" or elegant Gift Certificates for lucky recipients. In addition to Live Maine
Lobsters in three sizes, we also offer Caribbean, African, and Australian lobster tails, gourmet
steaks, other seafood, delicious appetizers and desserts, and more!'>
  <meta name="keywords" content="Live Lobsters, Lobster Tails, Surf and Turf, Dinner Package,
Seafood, Appetizers, Desserts, Crab, Clams, Gift Certificates, Maine, Caribbean, Specials,
Storefront, Ordering, Fresh, Lobster Gram, Livelob, Great Gourmet Gifts, Gourmet, Gifts, Holiday,
Lobstergram, Gram, Dungeness, Filet Mignon, New York Strip, New England, King Crab, Snow Crab,
Claws, Stone Crab, Shrimp">
  <!--Lobster Gram is the number one Live Lobster Gift Delivery company in America. Our secure
on-line storefront makes it easy for you to purchase "Great Gourmet Gifts" or elegant Gift
Certificates for lucky recipients. In addition to Live Maine Lobsters in three sizes, we also
offer Caribbean, African, and Australian lobster tails, gourmet steaks, other seafood, delicious
appetizers and desserts, and more!-->
```

"tricked out" with search engine indexers in mind. It's called a doorway because it's not really designed to be part of your Web "house," just an entryway. The page contains numerous links to various locations throughout your site (which indexers will follow, remember), but there are no reciprocal links from the "real" Web site back to the doorway page. It's one-way only—a humane trap for indexing spiders!

How do you "trick out" a doorway page? Not only do you include all the search engine-friendly elements I've been describing, but you construct the content and layout to attract them as well. Use lots of keyword-laden text (you can re-use copy from other pages if you'd like), lots of links, just a few fast-loading graphics with descriptive ALT tags. Don't bother adding cool navigation bars or funky JavaScript tricks, you want this page to be accessible to anyone, anywhere, regardless of browser version. Besides, the indexers like text links better than graphics links.

While there's no way for site visitors to click on a link leading to the doorway page, remember that some carbon-based lifeforms (not just 'bots and spiders) will see the page because it's likely to appear as a "hit" from a search engine. So don't just fill up the page with a thousand lines of keywords! Make it a real page, with real text, sharing some of the same "look" as the actual site. Add lots and lots of links to places in your site the visitors might like to visit.

When you submit your site to the search engines, don't forget the URLs of the doorway pages!

Adding Goodies

Okay. You've got your HTML working, you've got GIFs and JPEGs looking their best, made a clear layout with tables and/or frames, added some well-designed forms and some slick JavaScript bells and whistles. But what else might your Web site contain? Oh my dear, many things.

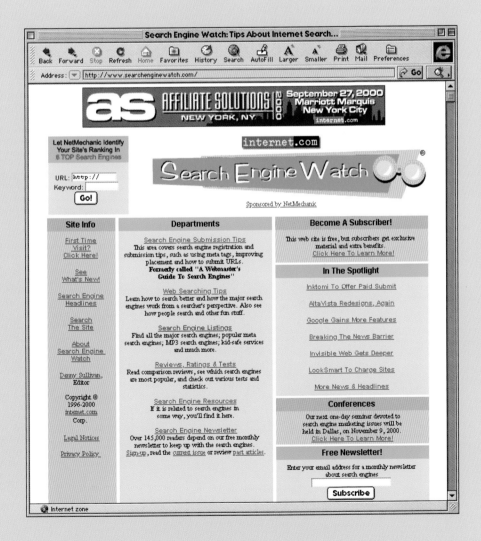

Product Search
Web-Wide
Auction

Search Tools
Search Trends
Search Guides
Maps
Directions
Yellow Pages
People Search
Translate

About AltaVista
Contact Us
Advertise With Us
Affiliate Network
Business Solutions
Terms of Use
A CMGI Company
Add a URL
Text Only

Sign Up Now and earn 1,000 pts. It's free and easy!

Find by Category

Arts & Entertainment
Movies, TV, Celebrities, iCAST...
AltaVista Entertainment

Auctions
Web-Wide Auction
Watch, Bargain Auction, Find Hot Deals

Autos
Classic, Dealers, Manufacturers...
AltaVista Autos

Business & Finance
Industries, Small Business, Investing...
Raging Bull Boards

Home & Family
Kids, Houses, Consumers...

Internet
Chat, E-mail, Internet Service Providers ...

Jobs
Job Search, Resumes, Career Planning...
AltaVista Careers

Law
Attorneys & Law Firms, Legal Support, Resources...
AltaVista Legal Help

Music
MP3, Bands & Artists, Styles...

Recreation & Travel
Food, Outdoors, Humor...
AltaVista Travel

Reference
Maps, Education, Libraries...

Regions & Languages
World, US, Europe...
AltaVista World Channel

Science
Biology, Psychology, Physics...

Shopping
Web-Wide Auction, Compare, VWWV Sites...

Where's WaldURL?

If you don't feel like waiting around for a search engine spider to get to your site, you can manually submit your URL to the search engine. Sometimes it takes a bit of hunting to find out where you're supposed to do that. Shown here is the bottom half of the AltaVista search engine home page. Can you find the link for adding your site URL to its database?

Danny Goodman's Search Engine Watch site provides insider-level information about which search engines use which elements of your site to increase your ranking. Sign up for the free newsletter!

Search Engine Myth-Busting

There's this widespread belief held by many Web users, especially among the client species, that search engines are on top of the whole Web site scene, that their databases contain the URLs of close to 100 percent of all the indexable Web pages out there, that it takes about a week for new sites to get added to the database, and that search engine rankings are the primary measure of a Web site's success.

What in that paragraph is actually true? None of it, except for the belief part. Let's take these myths one-by-one:

Search engines are on top of the whole Web scene.

Unfortunately, no. Maybe back in mid-1995, search engine pioneer Lycos was able to keep track because the universe of Web pages was relatively small and new ones weren't coming into being all that quickly. In early 1999, the most recent figures I could find, the count of "indexable" Web pages—ones that search engines have access to—was estimated by computer statisticians at the respected NEC Research Institute to be 800 million pages. That would take an indexing program about 76 years to compile, assuming it could do a page in 3 seconds and worked nonstop. The search engines are not on "top" of the whole Web scene, though they're the best we've got.

Their databases contain the URLs of close to 100 percent of all the indexable Web pages.

Now you know that's not true, but do you care to hazard a guess as to the real percentage of indexed sites? Eighty percent? Fifty percent? Try 16 percent, and that was the top-performing search engine—Northern Light—according to the NEC study. AltaVista came in second with about 15 percent, and close on their heels were Snap and Hotbot. The results from poor Lycos showed their database contained less than 3 percent of all indexable Web pages!

In this section I'll provide an overview regarding advanced-level features that make sites truly interactive, that add specialized functions, and in general provide a venue for moving beyond the capabilities of HTML while we all wait for the World Wide Web Consortium to catch up.

While your Web-authoring program may have "hooks" that allow you to configure interaction with other programs, or to bring in non-HTML files and embed within a page, how you actually create those files is a subject you'd best follow up with in

It takes about a week for new sites to get added.

As you can see, sometimes you'll never make it in! It helps if you take a proactive approach and physically submit your URLs to the search engines instead of waiting for their indexing robots to get to you. Even then, though, with few exceptions their own Submit pages will tell you it'll take weeks or months for your submittal to be added.

Search engine rankings are the primary measure of a Web site's success.

I agree that consistently coming up in the top ten or twenty hits on the major search engines is a coup and can only help drive traffic to a site. I don't agree that it will guarantee a site's success though, unless the site goals mainly depend on how much traffic it gets, regardless of what the traffic does when they get there. And as for serving as the primary measure of its success? Hogwash! By definition, a measure is something all players can achieve at different levels. And as you can see, at least 84 percent of us never get on the board at all, through no fault of our own.

There are a lot of other ways to promote your site and to drive traffic to it, some of which I discuss in chapter five in the section Site Promotion and Traffic Analysis. As far as the big search engines are concerned, the best you can do is optimize your site (as this section discusses) in the eventuality an indexer makes it over your way, and to individually submit and resubmit your site URLs to the search engines every few months. Beyond that, it's out of your hands.

another book (see the Appendix). Often, though, you'll find it more cost-effective to bring on a freelancer or consultant who specializes in that field to work with you. After all, how much can one brain hold?

Again, this is just an overview, meant to open your eyes to what's possible, and point you to resources to help you make your Web site a truly robust and useful member of e-society.

CGI scripts (aka Perl scripts)

Would you like to add a bulletin board to your site so people can post online, threaded discussions? Conduct an auction a la eBay? Run banner ad rotations? Install a site search engine? All these features, and hundreds more, are available to Web authors free via the magic of CGI scripts.

CGI (Common Gateway Interface) scripts are little programs that run on a Web server and that interact with the Web browser. Using form tags, you set up your Web

CGI yi yi

There are numerous sites on the Internet where you can download pre-written CGI programs ready to install on your Web server, for free. The venerable Matt's Script Archive is one of the most well-known of these. Click on any of these links to find a number of CGI scripts that fit the category, ranked by user satisfaction rating.

Matt also provides easily understandable instructions on his site, and many of the scripts come with their own ReadMe files.

page to send some information the visitor has input to the CGI script; the script does something to the information, then responds by posting a completely new Web page to your site within seconds.

The programs are written in high-level languages like Perl (the most common), C, C++, AppleScript and Visual Basic. You could teach yourself how to write CGI scripts if you'd like; like JavaScript, it's within the realm of the possible and once you know it you'd be able to do all sorts of cool things.

```
#!/usr/bin/perl¬
#######################¬
#◇General◇Mail◇Form◇To◇Work◇With◇Any◇Fields¬
#◇Created◇6/9/95◇◇◇◇◇◇◇◇◇◇◇◇◇◇Last◇Modified◇6/22/99¬
#◇Version◇1.0¬
#◇Modified◇by◇Emil◇Briggs,◇Charles◇Brabec◇Burtland◇Jones¬
#◇Define◇Variables¬
$mailprog◇=◇'/bin/sendmail';¬
```

In most cases, all you need to do to a Freeware CGI script is modify a few lines of it in a text processor so it knows where the cgi-bin stuff is located on your Web host, and sometimes you need to add specific Web URLs or "mailto" addresses to replace default ones.

Once the script has been customized for our use, drag it to the cgi-bin folder on your Web server.

Need some help with Goodies programming? Try Exp.com or similar sites that connect independent techno-wizards and potential clients. This screen capture shows the results of a search for Java programmers.

But again, like JavaScript, learning how the programming language works is not necessary, because there are so many ready-to-go free and Shareware CGI scripts out there. All you need to do is find one (look in the Appendix for some great sites that list thousands of them), change a few of its lines in a text editor to target it for your site and upload the script to a special directory on your Web server called "cgi-bin."

Chances are you've already got a couple of scripts in your cgi-bin folder. Most Web host ISPs provide their clients with a starter set that includes fmail.pl (for e-mailing form data, which I discussed in the section Putting Pages Together); counter.pl, a script that puts a running visitor count on the Web page you specify and a guestbook script.

If you need to add a complicated or unusual function to a Web site, one for which you can't find a prebuilt CGI script, then put out a call for a hired gun. There are hundreds of freelance CGI programmers who'd be more than willing to custom-write a script for your purpose, or help you and your little-brain brethren to configure a particularly troublesome script you found elsewhere.

Sound and video

Many Web sites could be so much more useful if they not only described something in words and GIFs, but showed it in a video clip with a sound track or voice-over narration.

To do this, you first need to create the sound or movie and get it into digital format. Professional sound and video software will help you to do this, as well as edit it and save it in a highly compressed format so it's suitable for viewing or listening to on the Web. Alternatively you could hire someone to create it for you and give you the files on disk, or use stock sounds and footage available for purchase on CDs, just like stock photography.

Once you have the sound or video files ready to go, add them to your site following the instructions in your Web-authoring program's manual. Pay close attention to the options they make available; such as setting it up so it automatically starts playing as soon as the user arrives at the page (versus just showing a preview window or control panel so the user can start it up on their own). Think about what your audience would likely prefer and give them as much control as possible, and always provide a means for stopping the sound or video (like a Turn Off Music button) so they don't get in trouble at the office!

Keep in mind that not only do embedded sound and especially embedded video files take a long time to download, even after "Web-optimized compression," but they can also be tricky to configure cross-platform and cross-browser. You may need

Keep in mind that not only do embedded sound and especially embedded video files take a long time to download, but they can also be tricky to configure cross-platform and cross-browser.

It makes sense for Rivet Media to show QuickTime clips of some of its award-winning documentaries and corporate videos, and they're fun for viewers to watch. Is there a section in the site you're developing that would benefit from some video footage as well?

to have alternate pages using a browser redirect JavaScript so site visitors don't feel disappointed that they're using the "wrong" equipment.

Flash, Shockwave, Java Applets, Acrobat PDFs

These names refer to four different sorts of computer-originated, cross-platform multimedia files you can embed in a Web page. The files need to be uploaded separately to your site, and then you "call" them (make them open in the browser window) via HTML codes in the Web page, similar to how you get GIFs and JPEGs to appear. Your Web-authoring program manual will explain how to embed these files.

Flash: A Flash movie is an animation, sometimes interactive, created with Macromedia's Flash or Adobe's LiveMotion software. Because the artwork in a Flash movie is in vector format (like Illustrator and FreeHand drawings) instead of bitmap format (like GIFs and JPEGs), the images in a Flash movie are very small in file size yet have sharp, crisp details.

Images in Flash movies can be animated, have multiple sound tracks and can be programmed to respond to user input (clicking in a certain location opens a different HTML file or Flash movie in the browser window, for example). They can appear in a certain area of a Web page, or they can "be" the whole Web page—no HTML body content at all, except for the Flash movie.

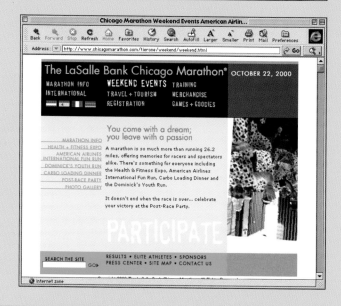

Macromedia's Flash technology is being integrated into more Web sites every day. Some sites are "pure" Flash, that is, the entire site is a single Flash file or series of them, such as the one for Everest Mint Gum. Almost everything is moving on this site, including the menu bar at the bottom. (I captured a moment in time when the menu was expanding, but you should go there for the full effect. Be sure to click on "Word from our Sherpas.")

Other sites embed Flash files into a section of an HTML-based site, such as the Chicago Marathon one. The lower right section contains animated video clips and type that changes for each section. In this section, the clips drop in from the grey section above it with an audible chik-click! before type starts moving to the soundtrack over it.

In order to see the Flash movie, users must have the free Flash plug-in installed in their browser folder, and it must be the correct version. When you save the Flash movie in the Flash-authoring program, you can have the software "wrap" the file in HTML and JavaScript code so it has browser and plug-in detect functions ready to go.

Shockwave: Macromedia Director, the premiere multimedia authoring program (often used to create interactive CD-ROMs), can save stand-alone movies in Shockwave format, a special format just for Web pages. With the ascendancy of Flash and its ever-growing feature set and popularity, you don't see many Shockwave movies in Web sites these days. However, if you've got existing Director movies that you'd like to repurpose, Shockwave is a likely solution.

Again, users need the Macromedia plug-in or ActiveX control to see the embedded Shockwave movie. Luckily the same plug-in is good for both Flash and Shockwave files.

Java Applets: Completely unrelated to JavaScript (see my explanation in the section Putting Pages Together), Java applets are small, stand-alone programs that are created in Java, a high-level cross-platform programming language. Like CGI scripts, you can either learn how to write your own applets (I have a pristine *Teach Yourself Java in 21 Days* book that's been gathering dust for three years if you're interested), or go to any of the hundreds of sites that offer Freeware and Shareware prebuilt applets. See the Appendix for URLs to these sites.

Many applets are little games or GIF and JPEG enhancements (if you're ever seen a Web image whose lower half appears to be reflected in a shimmering, moving lake, that's the infamous "lake" applet—it was cool for the first five minutes), others are purely functional, like calculators and time and date stamps. Probably the most well-known applet is the one that puts a "text ticker" scrolling across a Web page.

Java applets only run reliably in v4 or later browsers, and some of the free ones can be pretty buggy. The good news is that users don't need a plug-in to see them.

Acrobat PDF: Adobe's Portable Document Format (PDF) is a cross-platform format for any computer document, though it's mainly used to share text-based ones. You can create a document of any size, any length, in any program (QuarkXPress, Word, PowerPoint, even a calendar utility), convert it to PDF with the full Acrobat program, and it will look exactly like you designed it—fonts, pictures, layout and all—when opened with the free Adobe Acrobat Reader utility. Thus you

Installing the free Acrobat Reader utility from Adobe automatically installs the PDFViewer plug-in into the browsers on a user's hard drive.

With the plug-in, users who click on a link to a PDF file see the PDF appear embedded in their browser window. It's easy to quickly get spoiled by all the Reader tools that get added to that browser; I sure wish there was a way I could hang on to the Zoom tool!

If users don't want to see the PDF in the browser window, they can right-click to download it as a file to their hard drive.

can distribute your highly formatted documents to users on any platform without having to worry if they own the program you used, have the fonts installed and so on. The files are much smaller than the originals (if you include the size of the fonts and graphic files, that is).

Acrobat Reader, a free download from the Adobe site, is available for Macs, Windows, UNIX and DOS. They even have a little "Download Reader" icon you can use on your site.

What does this have to do with Web pages? When you install the free Reader application, a plug-in called PDFViewer gets installed into your browser folder. If you then visit a site that contains a link to a PDF file and click on it, the PDF will open embedded in your browser window, complete with the Reader toolbar goodies and navigation arrows for moving around a multipage PDF.

PDFs can interact with the Web even if they're not designed to be viewed embedded in the browser window.

Theoretically, then, Web designers could design a section or even an entire site in, say, QuarkXPress, using all of Xpress's layout and formatting features, all their fonts, overlapping text and graphics with abandon. They save it as a PDF document and upload it to their Web server. Then when users go to the site and click on the button that's been linked to the PDF, they see an amazing site that appears to somehow have gotten around all the boring HTML restrictions. Plus they've got this handy zoom tool, a built-in search engine, and more—all the Reader tools as well as their browser tools.

Well, it's been a few years already since the PDFViewer plug-in was released, yet I'm sure you've noticed that PDF Web sites haven't quite taken over the Web As We Know It. The problem is that PDF files, while compressed, are still much larger than the average Web page, especially if they're multipage documents. People don't like to wait for long downloads to view a page. Also, while millions of people have downloaded Acrobat Reader (according to Adobe), not everyone has, and people really hate to download and install plug-ins just to see your site.

Nonetheless, the PDF format is actually pretty popular—not for Web design, but for distributing documents on the Web. Many sites offer PDF versions of print publications like sell sheets, newsletters and annual reports which they invite users to download to their hard drive. They usually put up special instructions for bypassing the PDFViewer (right-click and choose Download File to Disk rather than using a direct click), so the page gets downloaded as a file rather than opened in the browser window, or they compress the file into .sit or .zip format so it comes in under the plug-in's radar.

PDFs can interact with the Web even if they're not designed to be viewed embedded in the browser window. Armed with the full Acrobat program, designers can

add graphic or hypertext links within the pages of the PDF that, when opened with Reader and clicked, will automatically open the browser (if it isn't open already) and bring the user to the URL contained within the link. Also, with the right tools you can make one or more PDF documents "searchable" within a Web site (and index-able by search robots), which could help users target the PDF they should download out of a large collection. And finally, the built-in and very powerful Forms features of PDF documents can be configured so that field data is automatically sent to a speci-fied CGI script on the Internet, which further processes the data (adds them to an existing database, for example), allowing the designer more freedom than HTML forms can provide.

OPPs (Other People's Programs)

Ranging from simple hit counters all the way up to e-commerce solutions, integrat-ing third-party Web-based programs (which are hosted on the owner's Web server) into your own site (hosted elsewhere) can be a smart way to add functionality to your site while keeping costs down.

Now, I'm not talking about using OPPs behind their owners' backs, of course. These companies want you to share their software, because they're either going to:

1. require that you run an unobtrusive credit line that links back to their site (so they can build traffic) on your Web site page that carries their software or

2. sell banner ad space on that page in your site or

3. allow you to use it "unbranded," but charge you a periodic fee to continue using their software.

Let me give you an example of how this works. Say you have to add a fully fea-tured shopping cart to a retail client's site you've designed. You found a few CGI or JavaScript shopping carts, but figuring out how to customize them for your pur-poses would take a year. Instead of turning to big-buck "e-commerce solution" server/database suites, or giving up all control over the site's design by using a mall-like service from Yahoo Stores, you could rent a shopping cart ($20 to $75/month) that's hosted by another company.

These companies leave it up to you to design the site as a whole and serve it wherever you'd like. But when users click the View Shopping Cart button on your site, they're sent to the vendor's secure site (with your domain name still appearing somewhere in the URL) where the products they've added to the cart appear under your logo. The vendor takes care of all the programming required for the shopping cart application: to keep a running total of what's in the cart, to automatically add shipping costs and taxes, to verify credit cards, to e-mail the new orders to your

One fine example of using an OPP (Other People's Programs) is the Atomz.com free site search engine. If it's powerful enough for Hotwired.com's "WebMonkey" (Web developer support) section, it's powerful enough for your site.

client, to track affiliate programs, and so on. As the designer, all you need to know are the form tags to add to the Add to Cart buttons, provided by the company's manual.

You can find similar Web-based "shared" programs for all sorts of features that would be difficult to create from scratch: site search engines, surveys and polls, maps, quiz engines, group calendars and schedulers, financial calculators, stock tickers—the list grows daily.

Unfortunately they're kind of hard to find; I haven't yet located a site that maintains an up-to-date, comprehensive list of OPPs for Web developers. (In fact that's why I'm calling them OPPs—I haven't heard of an industry term for them yet!) The Appendix lists a few starting places, however.

Before the Site Goes Live

Hey-hey! The production phase is over. You have bolded your last subhead, you have linked your last GIF. All the items are crossed off the Content List. The site is working perfectly on your hard drive. Just look at all those pretty pages.

Time to go live? Not yet. There are just a few more tasks to accomplish before you unleash your masterpiece on the world.

Upload the site to your Web server, if you haven't already done so. No one will know it's there except you and your client. For large sites, this task and the next are best started as soon as sections of the site are done, while you're in production for the other sections.

Just in case there's someone out there who knows your site's URL and periodically checks to see if it's "live" yet, consider burying the entire site in a subfolder on the server during the proofing stage. You can post a temporary home page at the root level in the meantime: "Acme's site is coming soon! Check back on June 1."

Final cross-checking

You haven't been forgetting to check periodically that your site works in all the browsers from all the platforms it's supposed to, have you?

It's time for one final check. Bookmark a selection of pages from your site—at least one for each main type of page, and every page that contains a form, interactive element or multimedia file. Then check each bookmarked page against the panoply of browsers out there (and remember that I'm writing this in 2001):

- Mac Internet Explorer v3, 4, 5
- Windows Internet Explorer v3, 4, 5
- Mac Netscape Navigator v3, 4, 6 (they skipped 5, remember)
- Windows Netscape Navigator v3, 4, 5
- America Online for Macs: v2, 3, 4, 5
- America Online for Windows: v2, 3, 4, 5, 6
- Opera (Windows only): current version and one back
 (the closest thing to a "competitor" for IE/Netscape)
- Lynx (Windows) or MacLynx (Macs): current version and one back
 (this is the most common text-only browser)
- WebTV browser: current version only (subscribers get automatic updates)

Pick yourself up off the floor! I'm not saying your site has to work perfectly in every one of these browsers. Typically, you can count on 95 percent of your site visitors using the latest or second-to-latest version of Netscape, IE or AOL's browser for their platform (Mac or Windows). But that still leaves tens of thousands of people

using some other browser from the list. Don't you think you should have an idea of how your site looks in them, in case they mosey down your way?

Now, only the most fully equipped Web design firm will actually be able to load these browsers, let alone test their site against all of them. I'm assuming that you have ready access to the browsers you are designing for—on both platforms. For the rest, you can post "site check" requests in Web designer listservs, ask your friends, professional colleagues and anyone else you know who's on the 'Net to check your site, and you can even purchase the services of a Web testing firm. Finally, there are some Web sites that will give you a preview of what a page or two would look like in some of these browsers (the WebTV site has one). I list the ones I know of in the Appendix.

What do you do if the site breaks down in one of the browsers you're testing? Tweak it, if it's a browser you think your site's audience will be using to any significant degree. Figure out a compromise solution so it works fine in all the browsers important to you, or create alternate pages optimized for specific browsers/platforms and use browser-redirect scripts so users aren't even aware of a problem.

When you're finished, it's time for 1) final proofing and 2) final sign-off.

Final proofing

Both you and the client need to go through each page of the site in its final form—online—and proof each link, image, form and interactive feature.

Text proofing: Blocks of live text, especially if they're long or contain numerical data, are difficult to proof on screen. Print out the pages from your browser and proof the hardcopy instead—preferably against hard copy of the text in its original format, like the print version of the newsletter or a printout of the original Word file the client sent you. For some projects, you may even want to hire a professional proofreader and have him or her send their marked-up corrections on hardcopy to you. Make all the corrections necessary on the local copy of the site and upload the modified pages to the Web server, replacing the incorrect ones.

Web proofing: To check everything else (other than blocks of live text), I normally work with a checklist, making sure that for each page in the site:

- Navigation bars/buttons are consistent page to page
- Navigation choices link to the correct pages
- Footers/headers appear on every page they're supposed to
- Footers/headers are consistent page to page
- Copyright date, phone numbers, addresses, e-mail addresses are all correct and current

Blocks of live text are difficult to proof on screen. Print out the pages from your browser and proof the hardcopy instead—preferably against hard copy of the text in its original format.

Keep ever vigilant of your sites whenever new browsers come out. Here's an example of a site that worked perfectly in every v3+ browser . . . until the Macintosh version of Internet Explorer 5 was released, after the site went live. Luckily the header section just needed its table coding tweaked to work correctly in that browser as well.

- All the GIFs and JPEGs that are supposed to be there are appearing correctly
- DHTML effects like layering, show/hides, animations are all working correctly
- Links to external URLs are working correctly (sometimes sites change their URLs and forget to tell you—the nerve!)
- Rollovers, drop-down menus, other JavaScript elements are working correctly
- Hypertext links open the correct page
- Links open up in the correct target (for framed sites especially)
- Formatting is consistent page to page (e.g., subheads have the same amount of space above/below)
- Layout is consistent page to page (e.g., "spacer" columns in tables)
- Media files such as sounds and video are working correctly, and the user's "Stop" button is working
- Colors are consistent page to page, especially for Link, Active Link and Visited Link (easy to forget to apply to a page or three during production)
- Forms work correctly, including CGI script and thank-you page

It's a happy day when you're finally ready to do this: Move your client's site folder from the staging area of your Web server to the actual "live" area.

- Surveys, polls, shopping carts, other interactive features work correctly
- Flash, Shockwave, Java applets are all loading and running correctly
- Downloads (such as PDFs) are downloading correctly and once downloaded, can be opened
- And. . .drumroll please. . .check to see that every page has a title! If you forget to add a title to a page during production, your Web-authoring program will do it for you with a default title. For a laugh, go to a search engine one day and enter "Untitled Document" or "Welcome to Adobe GoLive!" as your search phrase— holy moley! What a popular site!

Final sign-off

When all the proofing rounds and cross-checking tweaks are done, and your client is basically satisfied with how the site's working, get them to physically sign off on it. You need some form of documentation from your client indicating that the site is ready to be made public. Typically, my clients write something like "Site approved for activation on the Web server" on a printout of the home page, which they then sign and date.

Clients may be reluctant to sign off because they're afraid they may have missed a hyphen someplace and won't have the chance to fix it. To put their mind at ease, assure your clients that you'd be happy to make any minor corrections at no charge

during the first few weeks after the site goes live. Besides, you accounted for the "first month of site maintenance free" in your project estimate, didn't you? Of course you did.

Break Out the Champagne!

Here's the shortest section in the book.

If the site has been hiding in a subfolder, as soon as you get the green light from the client (sometimes they want to set an official roll-out date, corresponding with a press release or even a big party), follow three fast steps: 1) move it out of the sub-folder 2) toss out the placeholder "coming soon!" home page and 3) replace it with your site files.

That's it! Nothing left to do but add the URL to the portfolio page or your resume on your own Web site—you do have your own Web site, don't you?

No?

Get back to work!

Site Maintenance Strategies

Web sites are organic beings, just like the organizations or issues they portray. The company hired new people? The staff directory on the site needs to be updated. New services or products, old ones abandoned? The site needs to reflect those changes, because site visitors always assume that what they're seeing is up to date and get aggravated when they call to order an item or request a service your client no longer provides.

New discoveries from the R&D department, new projects completed, an upcoming appearance at a trade show, annual report just released; all these are great fodder for the Web site.

Besides simply keeping the Web site up to date with the changing face of the company, other modifications may sometimes be necessary. Two examples are:

1. You may have included certain pages that by their nature require regular updating and pruning: The home page's "News" or "What's New" blurbs, Calendar of Events, Upcoming Classes, Tech Support FAQs, Press Releases, Bulletin Board messages.

2. The client may be getting e-mail or phone calls from site visitors with valuable site feedback: content they wish existed, product pictures are too small, the text input field on the form doesn't auto-wrap, archives don't go back enough, pages aren't working with their browser, dead links or typos that you and your clients missed.

And other times site modifications won't be necessary, but the client would like to give it a face-lift. This may include updating the design to match their updated corporate identity, allowing for new features of the latest browsers, or just keeping up with the Joneses.

Major site update tasks like adding new sections or wholesale redesigns are best handled as separate, quoted (if subbed out) projects.

But some sort of plan needs to be put in place to handle everything else—the regular site maintenance chores like typo and link repair, and minor to moderate content updating. The plan needs to spell out the following parameters:

• Who's going to be the person in charge of collecting all requests for site updates and approving them for production?

• Who's actually going to be making the site changes and uploading new and modified pages to the Web server?

• What's the lead time for site updates (i.e., must changes be made within twenty four hours of each request, or can they be collected over a week or a month's time, and made all at once)?

Major site update tasks like adding new sections or wholesale redesigns are best handled as separate, quoted (if subbed out) projects.

Search Engines Love Updates

Even if there's absolutely nothing new to add to the site, it's a good idea to update something, anything, at least on the home page, on a regular basis.

Some search engines will boost your site's URLs in their rankings if their indexing 'bots detect that the page has been recently modified (the Web server carries this information). The logic behind this practice is that the more recently modified the page, the more likely the page has up-to-date information for its search engine customers.

• Who's going to proof the updated pages after they go live? Or should there be an additional step, a "staging" area on the site where new pages will go until they're approved?

• What should be done with the old, out-of-date pages? Should they be archived and saved for posterity, or is it okay to just replace or delete them?

Doing the maintenance in-house

If the site was designed in-house and will be maintained by the same crew, then you just need to hammer out the details as described above.

Things get a little trickier if the site wasn't designed in-house but you'll be maintaining it there. In addition to coming up with a maintenance plan, you need to request the site files from the vendor or grab them from the Web server (you should have a user name and password to do this) and copy them to a local hard drive. The Web site files, like their domain names, belong to the client, so there should be no problem with this.

The staff member in charge of production (the one who's "actually going to be making the site changes") needs to be trained on how to update the Web site and how to upload pages to the Web server. Depending on the person's interests and previous knowledge level, the training could range from a simple thirty minutes of "here's how the site is arranged" and "here's your user name and password for the Web server," to a harrowing week-long session of teaching a nervous assistant how HTML works, what a link is, how to use the Web-authoring software, what a Web server is, how to scan a new product photo and make a Web-ready JPEG, etc.

So choose the in-house persons wisely. Give them a generous honeymoon period to get up to speed and clear up their schedule to handle their new site maintenance responsibilities.

I highly recommend that if you're doing the site maintenance in-house you train at least two staff members for the task. Otherwise you can bet that the day your

In addition to coming up with a maintenance plan, you need to request the site files from the vendor or grab them from the Web server and copy them to a local hard drive.

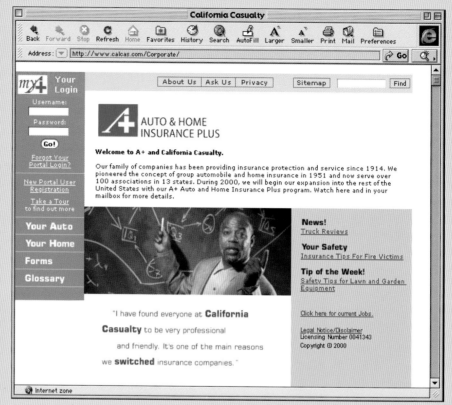

Keep your home page fresh by devoting a section to news and current events that lead visitors deeper into the site. Even the sparest of home pages, such as the promotional one for San Francisco-based HOT Studio, can find room to promote recent projects.

home page gets hacked, requiring an immediate fix by replacing it with an archived version, your site maintenance guru will be on the beach in Aruba, enjoying his well-deserved vacation.

Subcontracting the maintenance

Another scenario is that a company's Web site is wholly or partially maintained by an outside vendor (commonly, the company that produced the Web site). Even in this case, the client should always have a copy of the Web site files and access to the Web server holding their files in case their vendor falls off the face of the earth or a disagreement occurs.

The maintenance plan still needs to be worked out (who collects the updates, what turnaround is expected, who proofs) as just discussed. If the maintenance is being shared by both in-house staff and outside vendors, you have to figure out how everyone keeps up to date on the most current site files.

As far as billing is concerned, in my experience the simplest way to handle sub-contracting site maintenance is to set up a retainer arrangement with the vendor. Requests for updates often come in bits and spurts, and for the vendor, tracking the time it takes to implement each tiny update and billing for each one can exceed the amount of time to make the actual changes. With a retainer arrangement, time still needs to be tracked, but invoicing is easier. Other than the bill for the retainer itself, invoices only need to be generated when the total time spent on updates for a given period—a week, a month, a calendar quarter—exceeds the time covered by the retainer.

A simple way to handle subcontracting site maintenance is to set up a retainer arrangement with the vendor.

The retainer helps the client by allowing them to plan for and to budget a set dollar amount for site maintenance and to rely on the vendor to keep their sched-ules open to accommodate their work. Clients often benefit from a discounted hourly rate as well, as is usually the case with retainers.

So to set up a retainer, the client needs to tell the vendor what sorts of updates they'll need and an estimate of how often they'll be coming in. The vendor translates this into an estimate of the number of hours it'll take to complete the updates. Some sites are fine with one or two hours of maintenance a month (assuming even the smallest update will take at least fifteen minutes as is often the case); others due to their nature might need five to ten hours a week.

Because this is a retainer, the vendor will bill the client for the agreed-upon number of production hours in advance, usually at a discounted hourly rate. By accepting a retainer arrangement, the vendor is guaranteeing that they will keep at

All About:

Webmaster Resources
Links to what you need
Cool Button Trick
Low bandwidth designs
Writers On Writing
Get inspired or a chuckle
Server Logs
Understand your logs
Streaming Video
Energize your site
Grrrrrls...
Promote women's sites
Meta Tags
What they can do for you
Banner Advertising
How to get real value
And the winner is...
Where, when and how to earn web site awards
Site Reviewers Tell All
Insider secrets to help you
Doorway Pages
Get higher rank
Promo Sites
Other sites that'll help you
Webmaster Checklist
This won't let you down.
Web Software Reviews
Get the right tools.
Consultant Classifieds
Find consultants or offer your services.
Launch Tool Search
Find scripts for your site.
Subscribe to ezines from the JimWorld Team

Promote or Die

Promote or Die

Die

The section starting on page 128 is all about promotion and finding your audience. One thing the Web doesn't lack is a dearth of sites that provide advice on promoting your Web site. VirtualPromote.com (motto: Promote or Die) is one of the few grains of wheat among the overwhelming chaff. Shown is just one small section of the VirtualPromote home page, where they list some great online guides for site promoters. The site also has direct links to the "Submit URL" pages of over 500 Web search engines and directories.

least this number of hours open on their schedule for the client's work; even if they have to reschedule or job out other projects.

In exchange for all these accommodations, the client must accept that there is no "refund" available for unused retainer hours at the end of the cycle—they just start fresh with the usual allotment of hours at the next—and if the work exceeds the allotted hours in a given period, they will be billed for the excess amount at the vendor's normal hourly rate.

Obviously it's a good idea to regularly review retainer arrangements and to adjust them in light of actual hours used or upcoming projects (or lack of them)

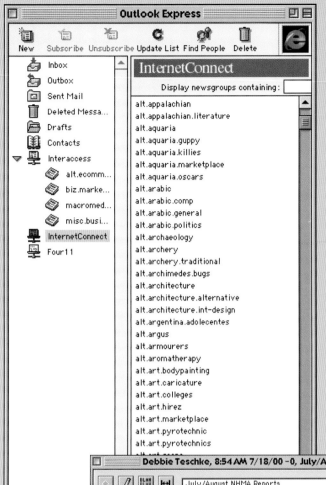

One of the best ways to promote a Web site is through "Web word of mouth"—in other words, via e-mail. One form of this is USENET, also known as Newsgroups. Newsgroups are public forums on different topics, for the most part run by users themselves. When you send an e-mail to the Newsgroup address, anyone accessing that Newsgroup can read it. You get access to Newsgroups when you get your dial-up account from your ISP, though you need special Newsgroup-reader software to access them (such as Outlook Express, shown here).

Out of the 30,000+ active newsgroups, there's got to be at least 10 or 20 that your target audiences read. Being an active member of these and always including a link to your Web site in your signature is a proven way of driving traffic to your site.

Another e-mail Web marketing technique is to start up a free e-zine or e-letter (magazine and newsletter, respectively) that gets sent to the e-mail addresses of your target audience. One of the ways NHMA promotes its housewares.org Web site is by sending out a notice whenever new issues of their association newsletter have been posted on their site. Each story summary is accompanied by a link leading readers to the whole story on the site. The cost to NHMA is minimal while the gentle marketing message ("We're on top of the industry") sent periodically to its members is just perfect.

Search engines are beginning to rank Web sites in their "hits" lists according to popularity level as well as relevance to the search term.

Site Promotion and Traffic Analysis

There is nothing inherently special about promoting a Web site. Like any other service or product, a potential group of prospects has to be targeted. Then you have to get your name (errr—your URL) out in front of that group in various venues they receive—print, broadcast, sponsorships, word-of-mouth, telemarketing, infomercials, billboards. So, of course, you should include your site URL in all your existing promotional and identity materials, as well as create new traditional promotions that focus just on the Web site.

What's different these days is the existence of the Internet itself—it's like the concept of a "magazine" was suddenly invented and grew to maturity in a five-year span. Just as a magazine provides many ways for a company to promote itself (display ads, classifieds, advertorials, inserts, even publishing a company magazine), the Internet offers a wealth of opportunities to spread the word about your company—or your Web site:

- Get in the top rankings of the major search engines (see the section Build Search Engine-Friendly Pages).
- Run banner ads that link to your site on other Web sites.
- Research other sites (vendors, colleagues, partner organizations, associations, industry directories) and request they add a hypertext link to your site, or trade links.
- Join an e-mail listserv that's devoted to a topic related to your company (or start your own if you can't find one), and provide helpful answers on a regular basis, being sure to include a link to your site in your e-mail signature.
- Sponsor one or more listservs or e-zines related to your industry—your sponsorship with a short marketing message and a link to your site will appear in each e-mailed issue (some e-zines have over 20,000 subscribers!).
- Start your own e-zine that combines timely, useful information and a soft selling pitch.
- Join any of the 30,000+ newsgroups that run on the Internet and participate with helpful, informative messages (again with a link to your Web site in the signature area).
- Submit your site to "awards" sites—there are hundreds of them! "Cool Site of the Day" is one of the biggest and most well known, but there are many more, some of them perhaps targeted to your specific industry. If you get in the winner's circle, you can post the award graphic these sites give out on your home page (or your Awards page if you win a number of them), and a lot of people, including magazine editors and radio personalities, periodically scout the winner's lists for story ideas.

Here's an interesting tidbit. Search engines are beginning to rank Web sites in their "hits" lists according to popularity level as well as relevance to the search term. Because they're in the business of indexing Web pages and the links they contain, search engines can easily track how many Web sites link to yours. If hardly any sites do, you'll never make it into the top fifty hits. But if hundreds of sites link to yours, the search engines assume that your site has some great information, so their search engine users will be most satisfied if they visit your site as opposed to the wallflower sites. And ... ZOOM! Your site appears in the top ten, even if it's not quite as relevant as some others.

Cruel, isn't it? Luckily, unlike real life, you can "pay" to be popular by offering a monetary reward for links to your site. (Or maybe that's too close to real life!)

Counting hits

Besides tracking how many prospects and clients mention that they've seen your Web site, how can you tell how popular it is?

Simple: Check the Web logs.

The what?

Every Web server, regardless of the platform it's running or the operating system it's using, maintains a log of every request for files it's received. The Web log is an ASCII file that sits on the Web server. Each line in the ASCII file represents one request for a file from a single user.

Usually, the Web host provider will set up their server so it creates and constantly updates separate log files—one per domain name—and will give you instructions regarding where your domain's logs reside and how you can download the file to take a look.

You might be thinking, Wait a minute, what if our Web site doesn't have any files that users might request?

Oh, but you do. To a Web server, every file in your Web site—every HTML document, every GIF, every JPEG—is a file that needs to be requested and downloaded. When you open your browser and go to a Web site, you're not looking at the Web page on the server, you're looking at a copy of the Web page after its elements have been downloaded to your hard drive. The HTML file is copied to your hard drive, then a new connection is made and you get a copy of the first graphic in that file, then a new connection, the second graphic, and so on, until you get the "page complete" message in your status bar.

Some pages might have thirty or more separate files that need to be downloaded to make a single "whole" page (each rollover is at least two images, so a navigation

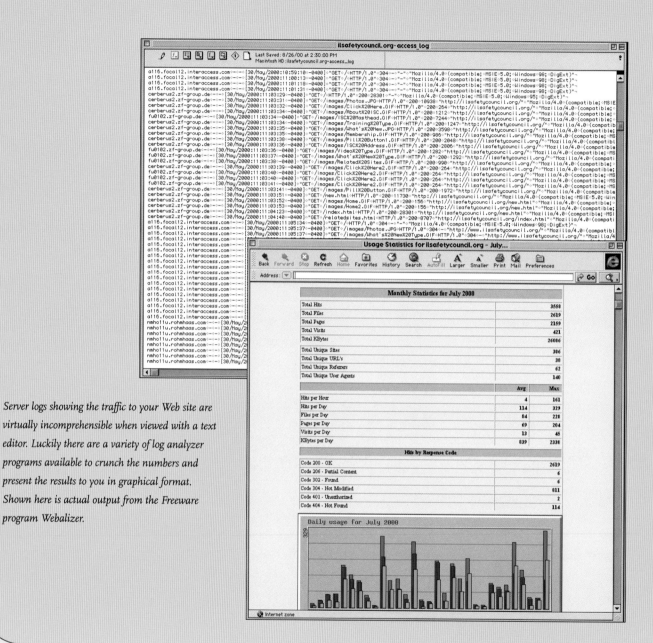

Server logs showing the traffic to your Web site are virtually incomprehensible when viewed with a text editor. Luckily there are a variety of log analyzer programs available to crunch the numbers and present the results to you in graphical format. Shown here is actual output from the Freeware program Webalizer.

bar made up of ten rollovers is twenty files). When you click a link on that page to open another page, or you click the Refresh button, once again the server starts sending you copies of all the Web site files for the particular URL you're requesting.

For each discrete connection you make—one for each Web page element—the Web server log creates a new line entry. It captures the following information:

- The date
- The exact time of day
- Your computer's IP (Internet Protocol) number—every computer connected to

the Internet receives an IP number—which is the unique number assigned
to every hardware device connected to the Internet to enable the network in
routing files and requests for files)

- The browser you are using, including version and platform
- The "referrer": the URL of the page you were on when you clicked a link for this
page (if that's what you did—if you used a Bookmark or entered this page's URL
by hand, it won't get the "referrer" information)
- The search term used, if you came to this page from a search engine
- The filename that was requested
- The results of the request (if it was sent, or if it generated an error)
- The exact time the connection ended (when the download was complete)

Amazing, isn't it? Not every Web log is configured to capture every bit of this
information (sometimes you have to request a referrer log separately from your Web
host ISP), but most are.

So you open the Web log in your word processor and you're stunned: How can you
ever hope to make sense of this? I mean, one person moseying around your site for
five minutes could easily generate hundreds of "hits" in your server log. Multiply that
by a lot of people over a lot of days, and you're talking serious number crunching.

The answer is to use a Web log analyzer. These log analyzer programs can batch
process months' worth of Web log files and convert them into nice-looking charts
and graphs that break down the information into something a normal brain can
comprehend.

At a glance, you'll be able to see not only how many hits your Web site got during
a given period, but more realistic numbers like how many page views (all the files
for a given URL = 1 page view) and how many unique visits (how many different IP
numbers) occurred.

Log analyzers also provide tables showing which pages are the most popular and
what time of day and which day of the week is busiest, they can rank user's browser
versions and platforms by popularity, and show which search engine 'bots stopped
by to say howdy, and so on.

Many Web hosts offer a free Web analyzer that runs on their Web server and is
pointed to their clients' Web logs. You and/or your clients can view the charts as
HTML pages in a password-protected directory. Alternatively, there are also
Freeware, Shareware and commercial Web analyzers available for any platform. All
you need to do is download the server logs and drag and drop them on the analyzer
software. The more expensive the analyzer program, the more reporting it can do.
FunnelWeb can tell you the average path users took through your site, on average

*Freeware, Shareware
and commercial Web log
analyzers are available
for any platform. All you
need to do is download
the server logs and drag
and drop them on the
analyzer software.*

how long they stayed and what was the most common entry and exit page. Check the Appendix for links to this and other analyzers.

One caveat: Web logs are not perfect. They can't capture reliable information from connections that cache (save copies of) Web pages to cut down on Internet traffic, a practice for which America Online is infamous. They can't tell exactly who is connecting, only an IP address, so if five different people are visiting your site from the same computer throughout the day (as might happen from an Internet café or even a home computer), it's going to show up as one unique visitor. The majority of consumers connect through either AOL (which we already know is a problem) or through a dial-up connection at their ISP, which normally assigns a different IP number to a client each time they reconnect—meaning the same user will appear to be different users—to the Web logs.

So it's best to approach evaluating Web logs from a more overall perspective: compare the log results of one time period vs. another, instead of comparing log results vs., say, results of telephone surveys.

Start Planning for Phase II

In five years, will your Web site look much as it does today?

I'm betting your answer is, "I doubt it."

Even if you're completely satisfied with how the Web site currently looks and performs, there will come a time when due to changing client demands, user expectations, advancing technology and business trends, you or your client will need to "reinvent" the site.

In the quicksilver world of the Web, keeping your eye on technology trends and translating them to your Web site is essential to stay ahead.

There is always a Phase II!

There's no time like the present to start collecting ideas for the next iteration of the site. Start, as we did way back in the beginning, with the goals for the site. Is the current site meeting those goals? Is there anything more you could do to help meet them?

I know of a company that sells gourmet food items on their Web site, and one of their goals, of course, is to sell more product. After the site had been running very successfully for six months, they started looking closely at their Web logs and discovered the most popular search term phrase people were using to find their site was "cooking manual" (not gourmet food)! This little neglected section of their site (titled "Cooking Manual," of course) where they had posted some instructions for making steaks was pulling in lots of prospects. So in Phase II, they decided to really expand that section with step-by-step photographs showcasing their products, sticking Add to Shopping Cart buttons right in the instructions. Their sales grew even higher almost immediately.

Here's another thing to consider for Phase II. In the quicksilver world of the Web, keeping your eye on technology trends and translating them to your Web site is essential to stay ahead.

Take, for example, a software company's Web site goal to "provide tech support information to our clients twenty-four hours a day." What happens two years from now when many of those clients are using weird little wireless devices to surf the 'Net? Will they be able to access the information? Perhaps as part of Phase II, the company should consider adding a companion "weird little wireless devices" Web site that's been formatted just for those types of connections, and use a newly invented browser redirect script on their home page to send it to them.

• • •

You and I have come to Web publishing at the start of its golden age. We are setting the standards; we are raising the bar; we are inventing whole paradigms that will need to be reinvented over and over again throughout our lifetimes.

I hope I've been able to guide you sufficiently through your first forays into this new world.

Here's to everyone's Phase II!

appendix

How This Appendix was Constructed

Included here are resources for books, software, Web sites, and e-mail discussion groups (listservs) that will help you to develop a professional Web site from start to finish (hmm, that phrase sounds familiar). I chose these particular resources—out of the sometimes hundreds of similar ones, especially in the case of Web-based resources—based on their being "the best of show" for their particular topic area and likelihood of their being around by the time you read this book.

This Appendix starts out with a "General Resources" section that lists basic reference resources. Subsequent entries are arranged more-or-less chronologically, following the Web development process outlined in the book, except for some rearranging I did in a few special cases to keep things more logical. For example, though I mention HTML in various chapters, I've grouped all the specific HTML resources into one section.

Any software I recommend is available for both the Macintosh and Windows platforms unless otherwise noted. I did not include version numbers nor prices since these may change. However, you can always find a link to the latest version of a software program by entering its name at either VersionTracker (for Macintosh software, www.versiontracker.com) or WindowsTracker (for Windows software, www.windowstracker.com).

Also, an up-to-date version of this Appendix, complete with hyperlinks, is available on my Web site at www.senecadesign.com/start-finish/appendix.html.

Note: Since current Web browsers don't need it, and to avoid repetition, I've eliminated the "http://" prefix for all Web site URLs. If the "www" prefix is also missing, that's not a typo—it is the correct URL.

1. General Resources

Books

In addition to this book and the manuals that came with your Web-authoring and image editing software, here is what you need to fill out your resource library:

Web Design in a Nutshell: A Desktop Quick Reference

© 1999 Jennifer Niederst (O'Reilly & Associates Inc.)

While this book is a bit long in the tooth (she wrote it in 1998), it's one of the most useful ones around for the more technical side of Web design, and most of the information is still applicable to sites you're working on today. Check to see if a second edition has been published by the time you read this.

Jennifer provides complete reference documentation, clear explanations and plenty of examples for the nitty-gritty details on almost everything you'll need to know to code a site, including: coding for different browsers and displays; HTML (including tables, frames, forms and server-side includes); graphics (including Web palette, GIF animations and transparency, progressive JPEGs, PNG format); audio and video Web formats, coding in JavaScript, Cascading Style Sheets, DHTML, XML and Internationalization.

Visual Quickstart Guide: HTML 4 for the World Wide Web

© 2000 Elizabeth Castro (Peachpit Press)

A book even my mother could understand (were she so inclined), this book goes through every tag in the HTML 4 pantheon, one tag per page. Each page's explanation shows a "View Source" and its companion "how it looks in the browser" screenshots of how a tag works, accompanied by step-by-step instructions for using it and lots of tips. This is the book I turn to first when I need a reminder of how to turn off frame borders or how to set the tab order in a form.

Designing Web Graphics.3

©1999 Lynda Weinman (New Riders Publishing)

Lynda's *Designing Web Graphics* (the ".3" indicates the third edition) is the definitive guide to creating the best-looking, quickest-loading Web graphics possible. In pixel-level detail she illuminates the ins-and-outs of file compression, transparency, anti-aliasing and basically everything there is to know about the GIF and JPEG file formats. In this latest edition, she also discusses techniques for using the latest Web graphics programs—Adobe ImageReady and Macromedia Fireworks—as well as Adobe Photoshop and JASC PaintShopPro.

Lynda Weinman is a California-based graphic designer and faculty member of Pasadena's Art Center College of Design. Early in her Web design career, she came up with the concept of the "Web safe pallette" which is now required knowledge for any Web designer.

Web design portals

A "portal" is a Web site that provides original content and an edited, comprehensive list of links to other Web sites' content for a particular topic. Their aim is to develop a user community (and to sell banner ads based on the user community demographics, of course).

Here are the best portals I've found for Web design, ones that have found a home at the top of my bookmark list. They contain up-to-date news, tutorials and tips for just about every topic listed in this Appendix, user forums, reviews and links to relevant software, books, and magazines, and more.

Note: The topic-specific Web resources I provide in the remainder of the Appendix are supplemental to the information provided in these portals. In other words, look here first!

WebMonkey
www.webmonkey.com

CNet Web Builder
home.cnet.com/webbuilding/0-3880.html?tag=st.cn.1-ron.sb.3880

Web Developer's Virtual Library
WDVL.com/WDVL/

About.com's Web Design
webdesign.about.com/compute/webdesign/

About.com's HTML/XML
html.about.com/compute/html/

Web design listservs

Toiling away at a Web site project can be an isolating experience. Seldom is there anyone in the office who can understand, let alone help you out with the numerous frustrations and inexplicable errors that occur daily in the development and production process. For the same reason, no one's around to congratulate you for having solved the problem!

Joining a Web design listserv (e-mail discussion group) is the answer. You can post messages asking for help with a coding problem, a referral for a Web host vendor or CGI programmer, or even to request a "site check" from members with a particular browser version. Answers typically come in minutes or a couple hours at most. You also learn a lot from other members' questions and responses to them.

To subscribe to a listserv, follow the instructions at the links I've provided here:

The Web-Design List
www.topica.com/lists/web-design

HTML Writers Guild (numerous lists)
www.hwg.org/lists/

2. Setting Up Your Workstation

Software
Virtual PC (Windows emulation for the Mac)
Connectix
www.connectix.com

SoftWindows (Windows emulation for the Mac)
FWB Software, LLC
www.fwb.com

Executor (Mac emulation for Windows)
ARDI
www.ardi.com

URLManager Pro (Shareware bookmark organizer, Mac only)
Alco Blom, author
www.url-manager.com/

3. Setting Up Accounts

Web resources
Broadband ISPs (DSL, cable and satellite):
DSLReports (locator service, covers all broadband)
www.dslreports.com

AOL's "Bring Your Own Access" billing plan
America Online
www.aol.com/info/pricing.html

Dial-up ISPs and Web Hosts
The List (locator service)
www.thelist.com

Domain Name Registration
ICANN list of approved companies
www.icann.org/registrars/accreditation-qualified-list.html

4. Site Architecture

Books
Information Architecture for the World Wide Web
© 1998 Rosenfeld & Morville (O'Reilly & Associates, Inc.)

Designing Web Usability: The Practice of Simplicity
© 1999 Jakob Nielsen (New Riders Publishing)

Web resources
Alert Box: Current Issues in Web Usability (Jakob Nielsen)
www.useit.com/alertbox/

5. Target Audience Capabilities

Web resources
Research Statistics on Web Usage
The Internet Index (free)
new-website.openmarket.com/intindex/index.cfm

Internet Statistics (free)
www.internetstats.com/

Gartner Interactive (pay)
www.gartner.com/public/static/home/home.html

6. Design Prototyping

Software
Adobe Photoshop, Adobe PageMaker, Adobe Illustrator
Adobe Systems Inc.
www.adobe.com

JASC PaintShop Pro (Windows only)
JASC Software
www.jasc.com

CorelDraw, Corel Photo-Paint
Corel Corporation
www.corel.com

QuarkXPress
Quark, Inc.
www.quark.com

Fetch (Mac-only FTP program)
Darthmouth College
www.dartmouth.edu/pages/softdev/fetch.html

CuteFTP (Windows-only FTP program)
GlobalSCAPE, Inc.
www.cuteftp.com

Web resources

Web Page Design for Designers (layout, color, typography issues)
Joe Gillespie, designer
www.wpdfd.com/wpdhome.htm

7. HTML References/Tutorials

Web resources

W3C (World Wide Web Consortium)
www.w3.org

W3C's official HTML specifications:
HTML v3.2 (1997): www.w3.org/TR/REC-html32#refs
HTML v4.0 (1998): www.w3.org/TR/1998/REC-html40-19980424/
HTML v4.01 (1999): www.w3.org/TR/html401
XHTML 1.0 (2000): www.w3.org/TR/xhtml1/

W3C's HTML Validator (checks your URL's code against latest approved specs)
validator.w3.org/

Web Content Accessibility Guidelines (accessible to people with disabilities)
www.w3.org/TR/1999/WAI-WEBCONTENT-19990505/

Web Designer Tutorials (HTML and more)
Tips and Tricks.com
www.tips-tricks.com/index.shtml

Joe Barta's Page Tutor
www.pagetutor.com/pagetutor/makapage/

CSS cross-browser, cross-platform compatibility chart
WebReview.com
www.webreview.com/pub/guides/style/mastergrid.html

DHTML cross-browser tutorial
www.dansteinman.com/dynduo/

Campaign for Accessible Site Design (accessible by any browser)
www.anybrowser.org/campaign/abdesign.shtml

8. Web Graphics

Software

Adobe Photoshop (comes with ImageReady), Illustrator
Adobe Systems Inc.
www.adobe.com

Macromedia FireWorks, Freehand
Macromedia
www.macromedia.com

Web resources

Web Graphics 101
builder.cnet.com/Graphics/Graphics101/

Bandwidth Conservation Society (GIFs and JPEGs techniques)
www.infohiway.com/faster/

The Browser-Safe Color Pallete
Lynda Weinman
www.lynda.com/hex.html

9. Content Conversion

Software
Microsoft Word, Microsoft FrontPage
Microsoft Corp.
www.microsoft.com

MacLinkPlus Deluxe (Mac file translations of Windows files), and
Conversions Plus (Windows file translations of Mac files)
DataViz, Inc.
www.dataviz.com

BeyondPress (Quark XTension for converting to HTML, Mac only)
Extensis Products Group
www.extensis.com/beyondpress/

OmniPage Pro (OCR program)
ScanSoft, Inc.
www.scansoft.com/products/ocr.asp

10. Web Authoring Programs

Software
GoLive
Adobe Systems, Inc.
www.adobe.com

DreamWeaver
Macromedia, Inc.
www.macromedia.com

HomeSite (Windows only)
Allaire Corp.
www.allaire.com/products/HOMESITE/

Web resources
GoLive tutorials/tips
Online training videos
www.adobe.com/web/tips/glvvtco/main.html

GoLive Heaven
www.goliveheaven.com/

GoLive Headquarters
www.golivehq.com/

GoLive Talk (e-mail discussion group)
www.blueworld.com/blueworld/lists/golive.html

DreamWeaver tutorials/tips
DreamWeaver Etc.
www.idest.com/dreamweaver/

DreamWeaver Depot
weblogs.userland.com/dreamweaver/

DreamWeaver Talk (e-mail discussion group)
www.blueworld.com/blueworld/lists/dreamweaver.html

HomeSite tutorials/tips
HomeSite User Guide
jeff.sci.shu.ac.uk/Refdocs/homesite/intro/index.htm

Unofficial HomeSite Repository
www.aliveonline.com/homesite/

11. Building Search Engine-Friendly Pages
(See Site Promotion, number 15, for more general search engine links)

Web resources
Search Engine Positioning Tutorial
www.ddsol.co.uk/

How to Use HTML META Tags
searchenginewatch.com/webmasters/meta.html

Submit It! Search Engine Tips
www.submit-it.com/subopt.htm

12. Adding Goodies (Interactivity, Multimedia)

Software
LiveMotion (creates Flash format files), and
Acrobat (PDF files)
Adobe Systems Inc.
www.adobe.com

Flash, Shockwave (created in Director)
Macromedia
www.macromedia.com

Web resources
JavaScript
Cut-N-Paste JavaScript
www.infohiway.com/javascript/indexf.htm

WebMonkey JavaScript Code Library
hotwired.lycos.com/webmonkey/javascript/code_library/

JavaScript FAQ
developer.irt.org/script/script.htm

Joe Barta's JavaScript tutorial
www.pagetutor.com/javascript/index.html

CGI Scripts
The CGI Resource Index (pre-made CGI's)
cgi.resourceindex.com/

CGI 101 (online class, tips, scripts)
www.cgi101.com/

Sound and Video
Multimedia Web Pages
html.about.com/compute/html/cs/multimedia/

QuickTime authoring tutorials
www.apple.com/quicktime/products/tutorials/

Real Networks' Streaming Media primer
www.realnetworks.com/getstarted/index.html

Streaming Media World
streamingmediaworld.com

Flash
Flashfever.com
www.flashfever.com

Flashzone
www.flashzone.com

Shockwave
Web page code for embedding Shockwave movies
www.macromedia.com/support/director/how/shock/run.html

Streaming Shockwave
www.macromedia.com/support/director/how/show/geofactsdemo.html

Shockwave content showcase
www.shockwave.com

Java
The Java Boutique (free applets, tutorials)
javaboutique.internet.com/

Java Spigots (free applets, tutorials)
www.spigots.com

Acrobat PDFs
Pure PDF
www.purepdf.com

Planet PDF
www.planetpdf.com

Shopping Carts/Ecommerce
EcomScope (complete list of 3rd-party products, reviewed)
rvdesigns.com/ecomscope/main.html

DXStorm (great shopping cart)
www.dxstorm.com

OPPs
Remotely-hosted CGI scripts (calendars, chat boards, etc.)
cgi.resourceindex.com/Remotely_Hosted/

ToolZONE "Clip-ons"
www.toolzone.com/clipons.html

Free-n-Cool (web-based services)
free-n-cool.com/freecrem.html

13. Browser Compatibility Testing

Web resources
Browser Archives (all current and previous browsers for downloading)
browsers.evolt.org/

Browser Watch
browserwatch.internet.com/

14. The Site Goes Live

Web Resources
Rouge & Blanc
www.rouge-blanc.com/us/

Moet & Chandon
www.moet.com/

15. Site Promotion

Software
WebPosition Gold (search engine optimizer software), FirstPlace Software, Inc.
PromotionSoftware.com/

Web resources
Search Engine ranking tips/links
Search Engine Watch (submission tips, news, research)
searchenginewatch.com

JimWorld/Virtual Promote (promotion tips and links)
www.jimworld.com/

The 1000.com (1,000 places to submit your site)
the1000.com

Banner Exchanges
LinkExchange (largest banner network)
adnetwork.bcentral.com/

Links to other Banner Exchanges
dmoz.org/Computers/Internet/WWW/Website_Promotion/Banner_Exchanges/

E-Mail listservs and E-zines (searchable database)
List Universe
list-universe.com

The Liszt
www.liszt.com

Newsgroups/USENET
Deja.com (complete archive of newsgroup posts)
www.deja.com/usenet

Start your own listserv/e-zine
eGroups
www.egroups.com

Topica
www.topica.com

ListBot
www.listbot.com

Awards
List of Award Sites (submit your URL)
webvivre.hypermart.net/_search/award%20sites.htm

16. Using Web Logs

Software (log analyzers)
Commercial software:

HitBox Pro
Web Side Story
hitbox.com

WebTrends Log Analyzer
WebTrends Corp.
www.webtrends.com

FunnelWeb Professional

Active Concepts

www.activeconcepts.com

Freeware (there are many more, this is the most popular):

Analog

www.analog.cx/

Web resources

A Web Log Sample Explained

www.jafsoft.com/misc/opinion/log_sample.html

Analyzing Web Logs tutorial

www.lost.co.nz/tutorial/logfiles.html

Acrobat PDF: A cross-platform format for any computer document, though it's mainly used to share text-based ones.

ALT tag ("Alternate" tag): An optional HTML tag that can be added to every GIF or JPEG image in a Web page to describe the image.

ASCII (American Standard Code for Information Interchange) (also **Text Only** or **plain text**)**:** The basic set of characters used by almost all computers. It is made up of unaccented upper and lower case

browser detect/redirect script: Special JavaScript code inserted into the header section of a Web page that, before the page appears on the user's screen, can detect the version of a browser that is calling the page. If the version of the user's browser isn't compatible with the code on the page (e.g., the page contains HTML v4-only code and the browser is at verison 2), the "redirect" portion of the script automatically substitutes another, lower-version HTML file with the same content.

glossary of web site terms

letters, numbers, the space, some control codes, and most basic punctuation.

bitmap: A computer graphic file that is internally coded as a single-layer grid of pixels arranged in regular columns and rows.

bookmark (also **favorites**)**:** A URL of a favorite Web page to which you would like to return, compiled under the "Bookmark" or "Favorites" function of a browser.

browser chrome: The collection of browser window effects that surround a Web page, including the favorites bar, large icons and the status bar.

browser-safe colors: The 216 specific RGB colors that will be available to site visitors regardless of the computing platform or strength of their color monitors.

cache: Save copies of previously viewed Web pages. Browsers create caches on users' computers to save download time. If the user revisits a Web page, the browser often will show the cached version instead, which is quicker than downloading the page's elements again from the Web server. Some ISPs, notably America Online, maintain vast caches of Web sites at their location in order to reduce traffic on their outgoing Internet connections.

carriage return: The Return or Enter key, which when pressed in a block of text will start a new paragraph. In HTML, new paragraphs created with a carriage return always have a blank line added above them (see line break).

CGI scripts (Common Gateway Interface scripts) (also **Perl scripts):** A series of commands written in a programming language (such as Perl or C++) that is saved as a text file and placed in a special directory of your Web server. CGI scripts allow the data your users enter into a form be "processed" by the script and return something interesting and useful to your users and yourself. A guestbook is a common example of a CGI script.

CMYK: The four standard ink colors—cyan, magenta, yellow and black—used in combination to create full-color images on a printing press.

contone (continuous tone): Grayscale or full-color images that haven't been converted to halftones for printing purposes; examples are prints or raw scans of photos and graphics with subtle shading and color gradations.

CSS (Cascading Style Sheets): HTML v4-specific text formatting and positioning codes that provide aesthetic and productivity enhancements to basic HTML text formatting.

descreening: The process of converting halftones back to continuous tones.

DHTML (Dynamic HTML): HTML v4-specific code commands which allow for layering and animations in a Web page.

Digital Subscriber Line (DSL): A high-speed "always on" digital connection linking a computer's network port to a digital modem, and from there connecting to the local phone company via a consumer-grade phone line.

dithering: A computer system's attempt to "fake" a color outside of its available color palette by mixing pixels of two or more closely related colors.

domain name: An easily remembered text-based Web address, such as www.acme.com. Special computers called Domain Name System (DNS) servers translate the domain name to the IP (Internet Protocol) address, such as 65.129.666.22, that actually is the Web address of a Web-connected computer. Users can register a custom domain name to use with all their Internet accounts such as Web sites, e-mail and FTP servers.

doorway page: An "entryway" page, much like an alternative home page, which contains numerous links to various locations throughout the Web site but which has no reciprocal links that will return a site visitor to that original page.

drilling down: Clicking to deeper and deeper layers in the site hierarchy.

elegantly degrade: The ability of a Web page containing advanced HTML codes to present a nicely designed and understandable page even if the user's browser version is too old to understand the advanced coding.

EPS (Encapsulated PostScript): A digital file that is partially or wholly defined by PostScript commands and requires output on a PostScript device for correct imaging. When saved in EPS format, the PostScript code of the file is "wrapped," or "encapsulated," within additional code that provides a low-res bitmap preview of the PostScript image when imported into other programs.

FAQ: The Internet jargon term for "Frequently Asked Questions," a Web page that lists common questions about a particular subject along with their answers.

Flash (also see **Flash movie):** A Macromedia program which produces files that can be embedded in HTML code, allowing interactive vector-based animation to appear in a Web page.

Flash interface: The graphics, text, links and animations created in Macromedia Flash that allow users to interact with your site.

Flash movie: An animation, sometimes interactive, created with Macromedia's Flash or Adobe's LiveMotion software.

File Transfer Protocol (FTP): A computer protocol (set of rules) governing how file transfers are managed between a client computer (a user's local computer) and a server (a remote computer that stores files) over the Internet network. To use FTP you must employ an FTP utility program. For Web design purposes, FTP is normally used to transfer files to and from the designer's workstation to the Web host company's Web server.

GIFs (Graphic Image Format): A standard cross-platform format for bitmap (pixel-based) graphics; GIF images are limited to 256 distinct RGB colors which is why their file size is so small.

graphic text: Text that has been entered in an image-editing program and saved as an image, rendering it static, non-selectable and all of one piece.

halftone: Images made up of only one to four colors of thousands of tiny dots of ink. Contone images must be converted to halftones before they can be printed.

hand-coded: Sites created outside a Web-authoring program, usually using a word processor and a thorough knowledge of HTML codes.

home page: The main or top-level page of a Web site that typically serves as its introduction, and contains links to the site's main sections.

HTML (also see **hypertext**): Plain text mark-up codes that define the formatting and design of a Web page.

hyperlinks: Text or graphics in a browser window that "link" to another location on the page, or to another page altogether.

hypertext: Text linked through the use of HTML codes so that clicking on it directs the browser to another page entirely.

intranet: A private Web site that's restricted to a company's employees and/or vendors and associates.

interactive elements: Forms, search engines, surveys, guest books, and other similar elements that allow the Internet user to interact with a Web site.

Internet Service Provider (ISP): A "middleman" company that leases access of their high-speed connections to the Internet to end users.

IP (Internet Protocol) number: The unique number that is assigned to every hardware device connected to the Internet to enable the network in routing files and requests for files.

Java Applets: Small, stand-alone programs that are created in Java, a high-level cross-platform programming language.

JavaScript: A computer scripting language that adds additional features to Web sites and can be included with the HTML source.

JPEGs (Joint Photographic Experts Group): A standard cross-platform format for bitmap (pixel-based) graphics that compresses the file size of the graphic by eliminating minute color differences between contiguous pixels. JPEG images have no upper limit to how many colors they can contain.

leading: The vertical measure of the space between successive baselines of text.

live text: Text that can be selected with the cursor and copied and pasted into a word processor. It appears in the user's default typeface at the default size (12 point on Macs and 16 point on Windows) with default leading that is approximately 120 percent of the point size.

line break (aka "soft return"): A keyboard combination (usually Shift-Return) that when entered in a block of text will force subsequent characters to begin on the next line. Web designers often use line breaks when they want to create a new

paragraph but not have an extra blank space added above it, as what would happen if they used a carriage return.

line screen: The lines of ink dots that make up a halftoned image.

listservs: The technical term for subject-specific, subscriber-based mailing lists based on e-mail.

META Description tag: A META tag which is made up of a sentence describing the Web site that search engines can read.

META Keywords tag: A META tag which consists of keywords about a Web site that search engines can use to categorize the site.

META tag: Tag for indicating site details such as auhtorship, languages used and contact information.

moiré: A pronounced plaid pattern appearance resulting from scanning halftoned images (that is, images that have already been printed).

OPPs (Other People's Programs): Third-party Web-based programs (hosted on the owner's Web server).

Optical Character Recognition (OCR): A program that converts scanned text to actual characters with varying degrees of accuracy.

page template: A Web page that has repeating elements already in place, with placeholder ("dummy") text and graphics standing in for elements that will have the same position or formatting but whose content changes from page to page.

Perl (pl): A scripting language used to create CGI programs that run on Web servers.

pixels per inch (ppi or dpi): A measurement of the resolution of a computer image; all Web graphics have a resolution of 72 ppi.

Portable Document Format files (PDFs): Documents that are converted from their originating program's file type to Adobe Acrobat's cross-platform document type (.pdf). They retain all original graphics, layout and fonts, and are compressed for quick downloading.

QuickTime: Common digital format for video and audio.

rasterized: A vector image that has been converted to a bitmap image.

Real Audio: Common digital format for streaming audio (audio that can be listened to while the file is downloading).

referrer: The URL of the page a site visitor was previously on when clicking a link to the current page.

RGB: The native color space of all digital color images, whose colors are made up of overlapping red, green and blue.

rollover buttons: Buttons which cause the button graphics to change when the mouse "rolls over" it.

search engines: Any one of a number of Internet sites that maintain an ongoing index of the text content of the pages in the World Wide Web; the engines allow users to search for matching URLs (Web pages that contain the text entered as a search term).

Shockwave: An interactive animation or program created with Macromedia Director software. Shockwave files can be embedded in the HTML code of a Web page and viewed by the user if they have the correct plug-in installed, similar to a Flash file.

site architecture (information design): Developing an optimal site structure by arranging the content within the site in a way that will be useful and effective to its intended audience.

SQL (Structured Query Language): The language used to address the data and structures within a relational database.

TIFFs (Tagged Image File Formats): A standard cross-platform format for bitmap (pixel-based) graphics; TIFFs can be gray-scale, RGB or CMYK. Saving a bitmapped image as a TIFF retains all of the color and pixel information, as opposed to saving it as a JPEG or GIF.

tile: A browser window's response to a background image smaller than the window, by which it will automatically fill the window background with repeated copies of that image.

Title tag: The text that appears as the window title when a Web site visitor is viewing the page.

toplevel: The root level of your site folder, where the home page is located.

Uniform Resource Locator (URL): The "address" of a Web page, that is, an HTML file on a Web server. Each Web page has a unique URL. The URL has three parts: The protocol (http://, ftp://), the domain name (www.acme.com), and the directory and actual filename of the document (/intro.html) in that domain name: http://www.acme.com/intro.html.

Web-authoring program: An application that helps users to create Web sites by automating much of the production process and the hand-coding of HTML tags.

Web host: An Internet account offered by most ISPs, providing space on their Web server for publishing your personal and business-related Web sites.

Web log: An ASCII file that sits on the Web server and logs every request for files that the server has received.

Web log analyzer: Programs that batch process months' worth of Web log files and convert them into nice-looking charts and graphs which break down the information in an understandable fashion.

World Wide Web Consortium (W3C): The organization of volunteer HTML gatekeepers.

copyright/permissions

index

rasterize, 82
Ray of Light site, 62
resolution, 82
retainer agreements, 125–26
RGB color, 67
Ritter Group, 34, 35
Rivet Media, 109
robots, 99
rollover buttons. *See* buttons, rollover
Rosenfeld & Morville, 140

scanning, 84–85
Search Engine Watch, 103, 147
Search engines, 99–102, 103, 104–05, 123,
 129, 144
Server logs. *See* web logs
shopping carts, 113–14, 146
selling, on Web sites, 43, 44
Shockwave, 109–10, 146
site
 architecture, 29–30, 140
 design presentation, 51–52
 development flowchart, 28
 goals, 29, 31–34
 indexers, 99–101
 promotion, 126–29, 147–48
 presentation, 69–74. *See also* prototype Web
 pages
 structure, 29–30, 41–42
software, 17–18, 139
 conversion, 143
 emulation, 139
 file translation, 82
 latest versions of, 136
 newsgroup reader, 127
SoftWindows. *See* Insignia SoftWindows
sound, on sites, 108–10, 145–46
Soundpunks.com, 34, 35
source code, 60
spiders, 99
statistics, 140. *See also* Web logs
storyboards, 46
Structured Query Language (SQL), 88
style sheets. *See* Cascading Style Sheets
Syngress site, 66

table cells, 62, 66
Tagged Image File Formats (TIFF), 72
templates, 93–94
text, 61–64
 converting, 81
 formatting, 60–64
 as a graphic, 64

preparing for production, 80–82
 proofing, 118
 static, 61
text labels (for links), 47
thank-you page, 99
Title tags, 100
traffic, 129–32
transparency, of graphics, 60, 85
tutorials, 143-44

uploading files, 16
UNIX, 85
Uniform Resource Locator (URL), 21. *See also* Web
 address
 creating, 91–92
URL Manager software, 24, 25, 139
USENET, 127, 148

vector graphics, 82
video, 108–10, 145–46
Virtual PC. See Connectix Virtual PC
VirtualPromote.com, 126
Visual Quickstart Guide: HTML 4 for the World
 Wide Web, 137

Web address, 21
Web-authoring programs, 51, 88–91, 143–44
Web Design in a Nutshell: A Desktop Quick
 Reference, 137
Web host. *See* host
Web host account, 20–21
Web logs, 129–32
 analyzers, 131–32, 148–49
Web Page Design for Designers, 141
Web page layout, 57–60
Web-safe colors, 68
Webalizer freeware, 130
Weinman, Linda, 137–38, 142
Windows emulation software, 17–18. *See also*
 Insignia SoftWindows and Connectix
 Virtual PC
Windows software
 and file extensions, 85
 on Mac, 16–18
Word. *See* Microsoft Word
World Book Encyclopedia site, 38
World Wide Web Consortium (W3C), 54–55, 141